WITHDRAWN

ART AND SOCIETY
General editor: Peter J. Ucko

NUBA PERSONAL ART

James C. Faris

UNIVERSITY OF TORONTO PRESS

*First published in North America
by University of Toronto Press
Toronto and Buffalo*

Printed in Great Britain

ISBN 0–8020–1857–2
Microfiche ISBN 0–8020–0187–4

CONTENTS

LIST OF PLATES

LIST OF COLOUR PLATES

LIST OF FIGURES

LIST OF TABLES

TECHNICAL NOTE

Consonantal orthography follows Stevenson (1956–1957:76), except that dental fricatives are noted —th— and —th—, the bar beneath the symbol indicating voicing. For vowels, *i* is as in English *sit*, *a* as in English *car*, *e* as in English *air*, and *u* as the initial sound in English *under*. A bar above the vowel symbol indicates tenseness and height.

In describing illustrations, *all* directions read from viewer perspective, i.e., right and left are viewer's right and left, respectively. Most photographs were taken with an Asahi Pentax 35 mm reflex camera, *f*1·4 50 mm Super Takumar lens, with Agfacolor CT 18 film. All black and white photographs in this book were printed from colour transparencies.

PREFACE

The field research of which this book is one product, was undertaken at various periods from December 1966 to April 1969, for a total of fifteen months while I held a Lectureship in Social Anthropology at the University of Khartoum. The research was financed by the Ford Foundation, the University of Khartoum, and a Fulbright award for advanced research and teaching (1967). Data analysis, photographic processing and preparation of the manuscript have been facilitated by the Research Foundation of the University of Connecticut. To all these agencies I am grateful.

The research was undertaken upon the generous permission of the Anthropology Committee of the Ministry of the Interior, Democratic Republic of Sudan. I should like particularly to thank Mohammed Abu Salim, Sudan Government Archivist and Secretary of the Anthropology Committee, for his help and many courtesies. He, Jaafer M. A. Bakhiet (now Dean, Faculty of Economics and Social Studies), and Prof. Omer M. Osman (now Vice Chancellor) of the University of Khartoum interceded on my behalf more than once when reactionary forces threatened to stop field research.

Several Local Government officials were helpful – Awad Allam, Abdel Rahim Bele, El Tayeb Awad, and Ahmed El Goni must be mentioned, all formerly of the Tegali District headquarters in Rashad, Kordofan. And I must acknowledge the Native Administration authority for the region in which I worked, Nazir Abdel Rahim Radi of Abu Gebeiha, for his generous hospitality.

Many other persons helped in many ways – necessary ways, when field research is so isolated. I must mention in particular El Goni Abdel Rahim, Abdel Ghaffar Ahmed, Abdel Basit Saeed, Amna Beshir, Yusuf Abdulie, Ismael El Boushi, Yusuf Fadl Hasan, David Brownwood, and my colleagues in the department of Social Anthropology at the University of Khartoum; Farnham Rehfisch, Lewis Hill, Talal Asad, Wendy James, Ahmed Al Shahi and Taj El Anbia El Dawi. We had a unique system of sharing teaching loads so that we might all have maximum time in the field – doing research for which there would have otherwise been no time.

More immediately, I want to thank Maurice Bloch for making a preliminary suggestion for the publication of this book in the series edited by Peter Ucko. Edmund Leach and Dell Hymes encouraged and urged me to get the material to press. And I must acknowledge the work and comments of William Watt, which have provided great stimulus – to more, in fact, than can be treated in the present volume.

My wife, Jenifer, and our children must be acknowledged for coping with situations that would have defeated others to share with me the field research – including days of heavy sand driving packed into a single overloaded Land-Rover, and extremes of heat, insufficient water, and occasional physical danger. The success of the research is in large measure due to their enjoyment of, and participation in, Southeastern Nuba village life.

The Southeastern Nuba – who will probably never see this book – did not ask that I be sent, and in any case would probably have had little choice in my stay. But they accepted my family and me, allowed us to share their activities, and patiently helped me to learn the language and document and understand not only their personal art tradition (which was a minor part of the research) but also their social organisation and rich ritual life. I must publicly acknowledge the vital help of my two closest friends among the Southeastern Nuba, Jabor El Mahdi Tora and Poba Aria Tora.

As fieldwork was centred primarily on aspects of social organisation, I was not prepared to undertake extensive photographic research. But after I had first witnessed the personal art tradition I did attempt to photograph what I could and whenever I could – but it was normally only what I was able to do while pursuing other researches. Moreover, it was difficult to secure permission to take photographs in pagan areas, and the June 1967 Arab-Israeli war (which closed Suez) made it extremely hard to get film. I was not, in short, able to get photographs of the majority of designs I witnessed.

The publication of a book such as this raises questions about its use in developing nations. The Southeastern Nuba are in no way representative of the vast majority of citizens in the modern Democratic Republic of Sudan. They con-

stitute a unique and isolated society, whose traditions, as documented here, will undoubtedly be dead within a generation. I should emphasise that I feel that it is probably not in the national interests of new socialist states that art traditions such as those described in this book survive. That is an issue which must be objectively determined after study.

But it is very much in the interests of the State that such traditions of a classless society be documented and analysed before they die, and this book is offered as a contribution to the rich legacy of the Sudanese people. The ethnographic heritage of the Democratic Republic of Sudan is critically important to the development of national form and socialist consciousness. Local traditions cannot be legislated away by parliamentarians or suppressed because they are contrary to religious interests such as Islam or Christianity – it must be established that such traditions are not in the ultimate interests of the people in a democratic state and must be changed for progressive reasons. I hope this study may contribute to an understanding of one such tradition.

More modestly, I hope the book will be of some contribution to iconic theory and to the analysis of natural graphic systems. The study is only preliminary and more research is, of course, needed – but perhaps this book will indicate some of the directions in which I am convinced that such research must go.

<div align="right">
J. Faris
Storrs, Connecticut
January 1971
</div>

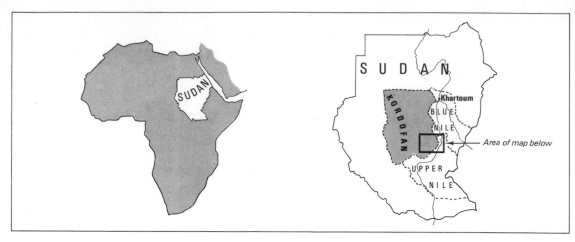

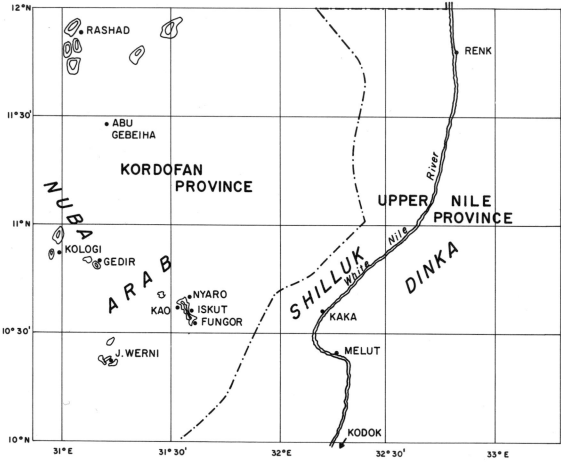

4 Southeastern Kordofan Province

(Southeastern Kordofan Province, North-
western Upper Nile Province)

INTRODUCTION

THE FUNCTIONAL TRADITIONS

Several general traditions characterise the description and analysis of tribal art –
which in one way or another may be labelled functional. Arnheim (1960:103)
touches on several of these:

> 'Typically primitive art springs neither from detached curiosity nor from the
> "creative" response for its own sake. It is not made to produce pleasurable
> illusions. Primitive art is a practical instrument for the important business of
> daily living. It gives body to superhuman powers so that they may become
> partners to concrete intercourse. It replaces real objects, animals, or humans,
> and thus takes over their jobs of rendering all kinds of services. It records and
> transmits information. It makes it possible to exert "magic influences" upon
> creatures and things that are absent. Now what counts for all these operations
> is not the material existence of things but the effects that they exert or are
> exerted upon them. . . . Thus, for example, in the representation of animals
> the primitive limits himself to the enumeration of such features as limbs and
> organs and uses geometrically clear-cut shape and pattern to identify their
> kind, function, importance, and mutual relationships as precisely as possible.
> He may use pictorial means also to express "physiognomic" qualities, such
> as the ferocity or friendliness of the animal. Realistic detail would obscure
> rather than clarify these relevant characteristics.'

In general these traditions deny the 'primitive' art for enjoyment or for purely
aesthetic or decorative reasons. Even studies and commentary on ethnological
art treat aesthetic considerations as exceptional (see Haselberger, 1961:347–8

5

and Lévi-Strauss 1969:105). To the contrary, however, the present study will document an artistic tradition that is chiefly motivated by aesthetic and decorative factors. Certainly in tribal society there are commonly functional attributes and social and cultural constraints to a graphic art – if for no other reason than that in classless societies, art traditions are more universal and the relationships between art and other spheres of social behaviour are many and multiplex. But I see no necessary reason thus to deduce that all art must be 'practical' in the sense of the quotation above. In the art tradition documented in this book, the purely decorative aspect will be seen repeatedly – particularly in the adaptation of new representations (cf. p. 18 below) and in the deliberate orientation of the art for viewing (cf. p. 68 below).[1]

Southeastern Nuba decorative art is not concerned with the reproduction of 'qualities' of representations – animal species are represented in ways essential for cultural identification, but for no other 'qualities'. In these representations the signifier and the signified cannot be dissociated, and there is no significance in a semantic sense other than the representation itself (see below, p. 50). As will be considered, however, there are (1) aesthetic consequences and sanctions for the representations, and (2) for a commonly depicted portion of the representational universe, a syntax and morphology for generating and describing (in a linguistic sense) the representations. Neither of these features of representative designs have anything to do with 'qualities' of representations in any functional way.[2]

Other general functional 'explanations' have been suggested for tribal art traditions. Some are concerned with the social structural consequences of art forms and art traditions, and art in ritual is frequently the focus of this type of interpretation (cf. Turner, 1966; 1967). Turner (1966:82–83) expresses it thus: '. . . the three colours white-red-black for the simpler societies are not merely differences in the visual perception of parts of the spectrum: they are abridgements or condensations of whole realms of psychobiological experience involving the reason and all the senses and concerned with primary group relationships.' These 'explanations' involve ingenious analyses – but as general theoretical contributions they are eclectic and essentially unscientific and unproductive.[3] At best Turner's work may have validity for expressed Ndembu symbolic and ritual domains. It can hardly be regarded as relevant to scientific cognitive studies. There *is* decorating peculiar to ritual function among the Southeastern Nuba (see below, p. 43), but this is a minor and insignificant part of the general decorative tradition.

One potential 'function' which occurred to me early in the research involved the degree to which the representative art forms might manifest a type of graphic taxonomy. On investigation, there proved to be no viable correlations between the natural species taxonomy and the representations. While it is true that both

graphic representations and natural species taxonomies are logical orders, they are not congruent. Minimal taxonomic distinctions may or may not be represented graphically, but even if minimal taxonomic distinctions are graphically coded (cf. p. 112; Col. pls 1 and 2: *dūn* and *krendelnya* giraffe species, respectively), it cannot necessarily be assumed that the graphic distinctions are of a minimal order, as in the giraffe example above (cf. p. 112; Col. pls 9, 10, 11: several species of leopard, for which *more than one* semantic dimension is required graphically to indicate a *minimal* discrimination taxonomically). Sometimes the correspondences are close, but at other times there is little or no coincidence,[4] for Southeastern Nuba natural species taxonomies involve consideration of visually non-codable features, such as habitat (tree, hole, grass) and location (mountain, forest).

STRUCTURE AND FORM

The structural analyses of tribal art traditions are practically as varied as some of the functional analyses just discussed. Possibly the most prevalent of these concerns stylistic descriptions of form (cf. Boas, 1955; Holm, 1965). While these may be revealing, more often they are vague and not particularly rigorous, and much remains to be said about form in most tribal art traditions. Commonly, of course, studies of form follow on functional premises (cf. Arnheim, 1960:103; Boas, 1955; Carpenter, 1966).

Another more recent tendency (but with strong similarities to Boas, 1955) is the 'structural' method of C. Lévi-Strauss (cf. 1963a). Lévi-Strauss is interested in demonstrating fundamental structures of the human mind, and he finds these variously manifested in far-flung art traditions. Lévi-Strauss could be said to be primarily interested in the 'structure of meaning' (and 'meaning of structure') – even if the manifestations are non-representational. In the structural analysis of form, Lévi-Strauss seeks to elucidate the logical or psychological internal connections that transcend particular art traditions (Lévi-Strauss, 1963a:248). Our present level of knowledge of neuro-physiological and psychological processes, however, is not sufficient for us to consider this work of Lévi-Strauss as anything but speculation. And art traditions are, as the present study will indicate, normally of much greater complexity than is suggested by the manipulation of simple binary surface structures commonly characteristic of the work of Lévi-Strauss (cf. 1963a:245). Moreover, Lévi-Strauss does not appear to understand that cultural traditions (such as art) cannot be divorced from the class structure and means of production of the society, and thus classless societies may generate art traditions in which aesthetics and content vary greatly from those of class-based cultural traditions.

A number of quite recent structural studies are characterized by considerably more rigour, and seek to explain (account for) the manifested forms by a

description (demonstration) of the process of creation and the process of identification. This has been most fruitfully pursued in a series of yet unpublished (excepting the work of Watt, 1966) researches of Sturtevant on Seminole patchwork, Davenport on Solomon Island ritual bowls, Muller on archaeological material from the eastern United States, Friedrich on Tarascan pottery, and Hymes on archaeological material.[5] And there are undoubtedly researches in this area of which I am unaware.

These studies all share methodologies derived from generative linguistic researches, and regard the corpus of design forms as an iconic grammar (or morphology, as it turns out to be in most cases). The aim in each case is usually to analyse the production and identification of the graphic elements, and specify the judgments necessary for their cultural assignment. Watt (1966; 1967:22) has discussed the relationship between iconic researches and language in some detail (also see below, n. 50), and has pointed out that in progressing beyond the description of particular graphic sets, we may arrive at more general statements of iconic universals.

I have drawn on these latter researches in the analysis of some of the representational designs of the Southeastern Nuba. If nothing else, these researches reveal something of the depth and complexity of the cognitive processes which are involved in the production and identification of artistic phenomena.[6]

The organization of the present study requires some comment. Even though the art tradition discussed is primarily aesthetically motivated, the study of the context in which it is produced is important for several reasons. It is, of course, necessary to examine the sources of inspiration for the designs, the material used in the art, and the social rules surrounding the tradition – that is, who can decorate, how, when, and why?

More important, however, is the requirement to demonstrate that in a classless society, surplus labour which cannot be used to increase production (because of techno-environmental limitation) may be used in cultural endeavour. In groups in which culture and society are isomorphic, and in which ritual, art, and other domains of the superstructure are not alienated from the material base, elaborations in particular intellectual spheres should be anticipated. The material base of Southeastern Nuba personal art rests in the celebration of the strong and healthy body – a symbolisation of productive requirements – and the effort expended in this cultural direction does not conflict with social structure.

Part II is an analysis of the tradition itself – in content and in form – to elucidate the logic and demonstrate the structural consistencies in the personal art manifestations. This second part of the study also accounts for a portion of the representational designs of this art tradition in the generative analysis of their production.

8

PART ONE

Art in Context

The task of the present generation is to construct a history of things
that will do justice both to meaning and being, both to the plan and
to the fullness of existence, both to the scheme and to the thing.

G. Kubler *The Shape of Time*

CHAPTER ONE

The historical context

The Southeastern Nuba[7] consist of the occupants of the three small mountain-side villages of Kao, Nyaro, and Fungor, Kordofan Province, Democratic Republic of Sudan. The total population of these villages is something under 2,500 men, women and children, and the art tradition I shall be describing is peculiar to this small population.[8]

The Southeastern Nuba, who are relatively isolated from other Nuba groups to the west, northwest and north, are bordered by Baggara Arabs on the north and west, and Nilotic Shilluk to the east and south. They share a language family (a mutually unintelligible dialect[9]) with their nearest Nuba neighbours, the people of Jebel Werni, thirty-five miles west (see Map), and the Tira, Moro and Shwai peoples further northwest.

Their unique social organisation – a system characterised by duolineal descent and clanship, and fully functional matrikin (clan and clan section) groups and patrikin (clan and clan section) groups – probably has little to do with the particular art tradition found today among the Southeastern Nuba.[10] But many of the factors which gave rise to the present social organisation are probably the same sorts of pressures as resulted in the local art tradition – particularly factors such as isolation.

Personal art traditions of other Nuba peoples, Shilluk, and Baggara Arabs are poorly documented, but certainly they are not as visibly elaborated or unusual as the tradition of the Southeastern Nuba. Other Nuba groups have similar body

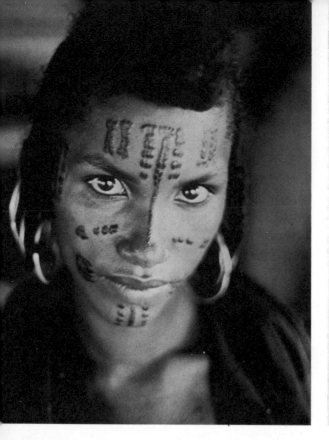

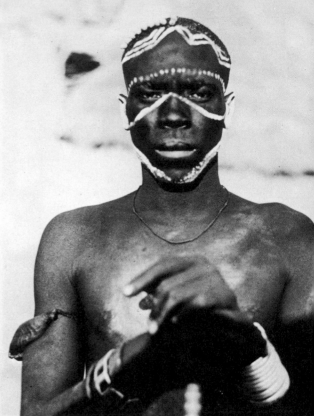

scarification, and apply colour and oil to themselves (cf. Luz, 1966), but with none of the elaboration characteristic of the Southeastern Nuba. Most of the other Nuba groups confine colouring to ash or small amounts of ochre, and its use is commonly restricted to occasions of ritual, sport or dance.

The adults of Jebel Werni (a society which has, in the past fifteen years, adopted Islam) remember the daily oiling and colouring of young girls, but I have no further data on this, and there are problems surrounding the information. As will be seen (p. 32), the oiling and colouring of young girls is a practice associated with patriclan section membership, whereas the social organisation of the people of Jebel Werni is matrilineally organised.[11]

The still-pagan Nilotic Shilluk people occasionally decorate themselves (cf. Col. pl. 17), but in a manner, both in style and execution, quite unlike the normal Southeastern Nuba practices. The Southeastern Nuba have adopted items of Shilluk culture, however, particularly in wood carving and metal bracelet styles (cf. Col. pl. 15).

Other sources of artistic influence are slight. Arab and West African (principally Fulani, see Pl. 1) tattooing have not been adopted, although both body and facial scarification are common to the Southeastern Nuba, to Arabs,

Plate 1
Sokoto Fulani facial tattoo (photograph taken in Southeastern Nuba territory, at the eastern edge of the movements of these nomads)

Plate 2
Kadūndōr with simulated Shilluk scars above the eyes (see Col. pl. 17)

12

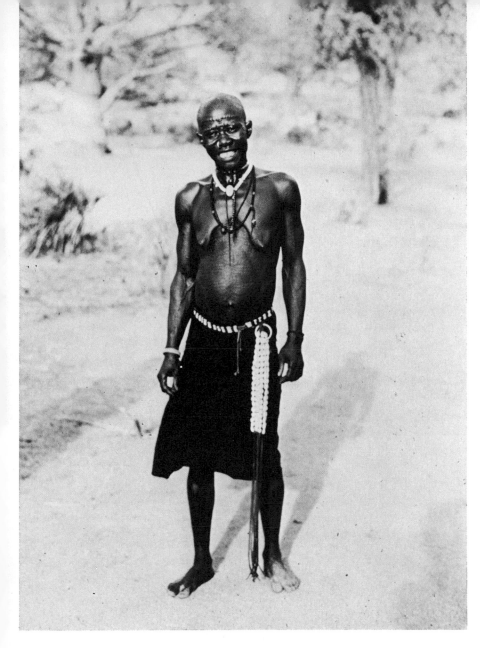

Plate 3
Southeastern Nuba
woman. The skirt colour
and cowrie belt design
indicate that she is past
childbearing

and to the West African nomads who migrate through southern Kordofan. The cicatrisation is quite different, however, both in form and execution, from the Southeastern Nuba. The neighbouring Shilluk have quite characteristic scars across their heads, but except for occasional imitation in facial *painting* (Pl. 2), Southeastern Nuba facial scars are unlike those of the Shilluk (see Col. pl. 6; Pls 3 and 4; and Fig. 1).

13

In sum, the overall external cultural influence on the local Southeastern Nuba artistic traditions is slight. Southeastern Nuba art appears to have evolved uniquely and *in situ*, on a general base of the use of ash, oil and occasionally colouring materials, plus body scarification, common to many groups, Islamic and pagan, in this latitude in Africa.

It is difficult to reconstruct the evolution of the local art tradition, but certain factors may be mentioned which were of considerable influence on it. The Southeastern Nuba have lived in the same area for at least 200 years. Oral traditions document that they were in place before the first Arab movements into the area (*c.* 1800, see Cunnison, 1966:3), and remains of surface habitation, genealogies, and linguistic separation from others of the *Koalib-Moro* language family all indicate an even greater time span.

The Southeastern Nuba are probably an amalgam of the matrilineally organised Southern Nuba (Mesakin, Talodi, Werni) to their west, and the patrilineally organised North Central Nuba (Tira, Otoro, Heiban, Shwai) to the northwest. Local society today is probably the result of an initial group of matrilineally organised migrants, who – perhaps influenced by later patri-lineally organised migrants – began to live patrilocally, evolving (or adopting) patrilineal descent and descent group functions atop the matrilineal descent groups. They share some matriclan names with their nearest matrilineally organised neighbours to the west (Jebel Werni), and certain patriclan names with the patrilineally organised Tira to the northwest. No other societies of the Nuba Mountains are today characterised by duolineal descent and clanship organisation.[12]

The evidence for the antiquity of the personal art tradition is varied. As will be seen below (p. 110), the most persuasive evidence for the age of the art tradition rests with the morphological structure of certain of the representative designs themselves. On nearby abandoned village sites (occupied before the Mahdiya period of the late nineteenth century) on mountain tops, there is plentiful evi-dence of red and yellow ochre which is commonly used today in colouring. And the same remains can be seen at an even earlier abandoned site a mile or so north of the present villages, on the plain.[13]

Another firm indication of the long history of the art tradition is to be seen in the large excavation made to extract ochre for decorative purposes (ochre has little other use in the society). This 'cave' (*tē taka wā* – 'hole of the haematite') is approximately two miles west of the village of Kao, and is the major source of haematite (ferrous oxide) for colouring. On the basis of crude measurements and incomplete exploration of the many passages and corridors (made by excava-tion), I estimated that several hundred cubic yards of yellow ochre had been removed. Moreover, this is not the only source of material available to the South-

a

b

Figure 1
Southeastern Nuba Facial Scars
(a – female; b – male)

14

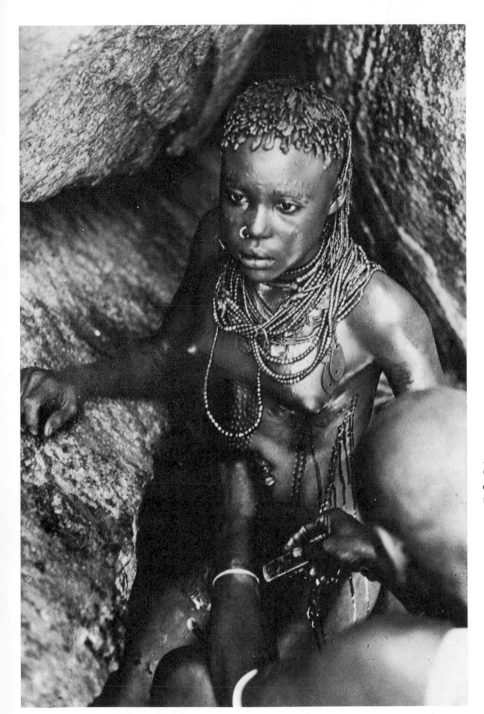

Plate 4
Girl receiving second set
of body scars (*karē*) at the
start of menses

eastern Nuba (see below, p. 61).

There have been several recent factors which have influenced the art tradi-
tion. Body and facial painting, the central and most spectacular art manifestation
of the Southeastern Nuba, was generally considered uncivilised, primitive and
repulsive by the British colonial government, and more recently, by a series of
Independence governments. The isolation and difficulty of access (Rashad, the
nearest seat of local government, is approximately 120 miles north over roads
impassable during the summer and autumn) has meant that the governmental
prejudices have not been well enforced.

The Southeastern Nuba, in a 'reserved' portion of the Nuba Mountains,[14]
were not subjected to Christian missionary activities, and escaped attempts from
this source to discourage the personal art tradition. On Independence (1956),
Islamisation was encouraged, but the formal effect of this has been slight, as few
khalwa (rural Koranic schools) have been established in the region chiefly be-
cause of its proximity to rebel territory south and east. Islam has made inroads in
local society in less formal ways, however, and will undoubtedly mean the de-
mise of the personal art tradition in the future. During my period of research this
was beginning with a few converts in the society – most notable of whom is the
local *omda*.[15]

Other modern changes have affected the personal art tradition in more sub-
stantive ways. Small hand mirrors, introduced after the British re-invasion
of the Sudan in 1899, have enabled artists to decorate their own faces (see Col.
pl. 20), instead of the faces of others, as was formerly the practice. This I suspect,
has given rise to more detailed and elaborate facial designs today. Just as today
one's own efforts are placed on another person's back, formerly they went also
on another person's face and nobody ever really knew what he looked like.

The twentieth century has also introduced new materials. Today additions
to the spectrum are possible, with the blueing (*zhar*) carried by Arab merchants
(see Col. pls 19 and 25) and bits of tin foil used in hair decoration. And, very
important, most oil and all beads are today bought from the itinerant Arab
merchants who spend the dry season among the Southeastern Nuba.

The environmental context

For the Southeastern Nuba the chief stimulus in design – particularly the representational forms – is their conception of their surroundings. The people of Kao, Nyaro, and Fungor are principally agriculturalists, but hunting and gathering are important, and sometimes critical, adjuncts. Men are superb hunters. They mainly use old Belgian breech-loading single-shot rifles (*c.* 1850) traded into the Sudan from various Abyssinian campaigns (most bear Ethiopic markings) to Arab nomads, who finally traded them to the Southeastern Nuba. The Southeastern Nuba make their own gunpowder – needing only lead, sulphur and matches (the latter for igniting caps) from market sources.

The last small hills of southeast Kordofan – before the country drops off to the White Nile basin (forty miles to the east) and to the swamps of the *Sudd* (to the south) – still have plentiful game and meat is usually brought back from every other hunt. Men are acquainted with the entire range of savanna, forest and mountain animals and their habitats and characteristics. The hunt is so important that several leading priesthoods of the Southeastern Nuba *marejena* (council of priests) are devoted to control over various species and over hunting success in general.

Knowledge of animals is critical in material ways – the rainfall at this latitude is not always regular or trustworthy, and famine is not uncommon.[16] The emphasis on hunting and animal knowledge, plus ritual control, thus results from firm necessity. For similar reasons, plants and insects are important. One

dietary supplement consists entirely of a series of leaf and root plants, which is critical for subsistence in times of crop failure. Locusts are not only eaten, but knowledge and ritual control of these insects are important for the damage to grain certain species may cause. To illustrate the extent of this knowledge and detailed concern for animal resources, I documented for the Southeastern Nuba over forty species of locusts – taxonomically elaborated from a corpus which probably contains no more than seven biologically distinct species. And various caterpillars are similarly treated because of their edibility and their destructive potential.

The concern with classification and taxonomic detail is present in several plant domains. Over twenty-seven species of sorghum are discriminated, from a corpus which in contemporary biological classifications consists of only three species. Along certain axes of this classification, separate ritual, storage, and function result – and perhaps logically, some decorative endeavour (see Col. pl. 13). Any child of ten or twelve can distinguish as many as a hundred species of trees, since many types of wood are critical for domestic uses in building and cooking. Leaves and fruits are often eaten, and various barks and other parts of the plant are used as medicines. Even bats, which are eaten, are classified into eight species of a single genus.

The point of this digression into Southeastern Nuba taxonomic efforts and the material base from which it stems, is that many species exhibit morphological characteristics that are visually coded in art forms – on hut walls and granaries; on beer pots and oil bowls; and on the body. The process by which many of these species are identified and represented in the personal art tradition will be discussed below (chapter eight).

The environment contains more than just plants and animals, however, and many things whose shape morphology can be identified and represented in two dimensions are sources of artistic expression. The mosque of Kologi (a small Arab village, approximately forty-five miles northwest, which has the nearest market) is represented, since its morphological outline is easily depicted and it is the most unusual building local people have seen. Aeroplanes, which people see in but one perspective, are also commonly depicted (Pl. 51) – their morphology being normally a careful representation of the angle of the wing to the fuselage and of the number of engines. Thus the several types of large high-altitude jets which fly between Khartoum and Kampala (and pass over the Southeastern Nuba villages) are discriminated graphically on the body. Lightning (Fig. 12), stars (Pl. 36), and landscape profiles (trees and mountains in outline) are also represented.

My own visit introduced new sources of inspiration – I once observed the Middle-Eastern skyline, which is featured on the back of Camel cigarette

packages, very accurately represented on a young man's back. And words and word strings – like snake designs (see Fig. 4) – are an extremely flexible form for use on the body. Young men from the village section in which I lived, who were frequent visitors, commonly used as design forms words and phrases which they had observed from prints on boxes in my hut. HUNTS (a manufacturer of tinned goods), LONDON, and KHARTOUM were commonly depicted.[17]

No distinction is made between representational designs and 'pure' design forms with no intended representation in Southeastern Nuba personal art. But certain representations are not used on the body, and are confined to hut walls and in designs scratched on to bowls and gourd dishes. These are the designs which tell stories or represent series of action (see Col. pl. 14 – the interior of a hut wall) – any designs used on the body must complement it, not distract from it, as would a series of action or a story.

This brings us to a point that will be repeatedly made. Whatever the source of the designs used on the body, the critical factor is that the body must be empha-sised, complemented, enhanced. No design or artistic treatment must detract from the presentation of the physical form itself – the chief reason, after all, for the personal art rests in the proper cultural exposure and celebration of the healthy body. Southeastern Nuba society demands and rewards physical strength, prowess and beauty – and this is why there are no body designs which would of themselves command excessive attention, such as a scene of action might. In Southeastern Nuba body decoration, the medium is the message. Some of the cultural implications of this will be discussed below (p. 49), and the several types of body forms and designs appropriate to them are analysed in chapter six.

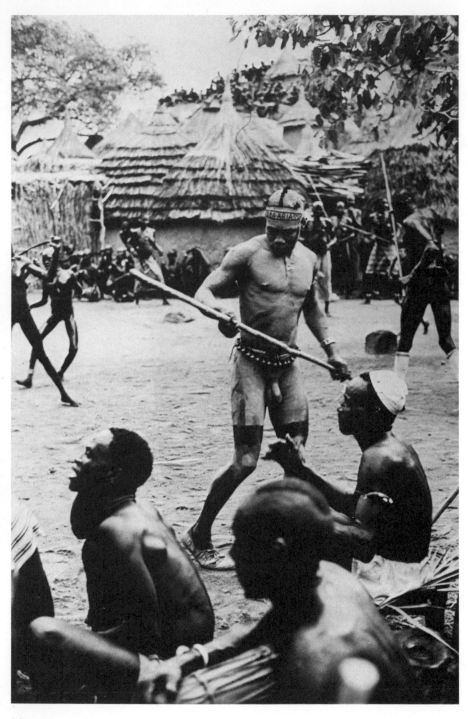

Plate 5
Kadūndōr prancing at
nyertuŋ dance. Note the
forehead design

20

The social context

While the motive of personal art is principally aesthetic, the art is in part dia⁄
critical; and body decoration not only follows precise social rules, but the decora⁄
tion itself commonly serves as a status indicator. Colours, styles, hair form,
scarification, and other aspects of personal art serve to mark age group status,
patriclan section membership, physiological condition and state, and, of course,
ritual status.

At the outset it should be mentioned that jewellery is common and is usually
free from cultural or diacritical social significance, display of wealth and decora⁄
tive effect. Younger women commonly wear brass ankle bracelets and wrist
bracelets (see Col. pls 8, 15 and Pl. 3), and young men and women wear on
their wrists small brass buckles strung on leather straps (see Pls 5, 6, 7, 8). Both
sexes wear ear⁄rings – on the top or at the bottom of the ear – and girls, particu⁄
larly the young ones, wear nose⁄rings or plugs (see Col. pls 1, 6 and Pls 3, 4, 6,
9, 10, 11, 12, 13, 14). Older women have lip plugs, but this custom is dying out,
and young girls no longer have their lower lip pierced.

Men and women wear beads – usually a single choker for men (see Col. pls
24, 25, 27 and Pls 7, 8, 10, 11, 13) and longer strings of beads of a variety of
types for women (see Col. pls 6, 7, 15 and Pls 3, 4, 9). Men also commonly have
a small silver (or aluminium or tin⁄can lid) disc with various designs stamped
into it (see Col. pls 4, 11, 12, 23, 26 and Pls 6, 8,10, 11,14,15, 16, 17, 18, 19) – a
piece of personal decoration which replaces the large stone bead (*lda*) they wore

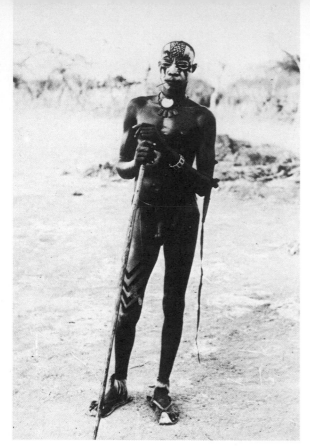

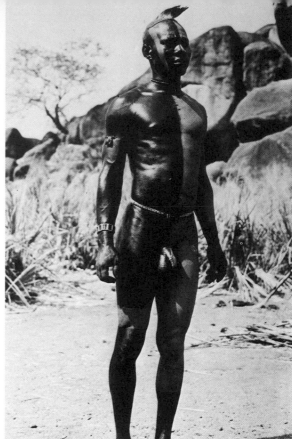

Plate 6
Lōer̯ youth with *wēā kōra̯* body design

Plate 7
Basic *t̯ōrē* design, with balance variations on the left side

Plate 8
Symmetrical non-representational facial design on the left, basic *t̯ōrē* body design on the right, with balance variation at mouth plane

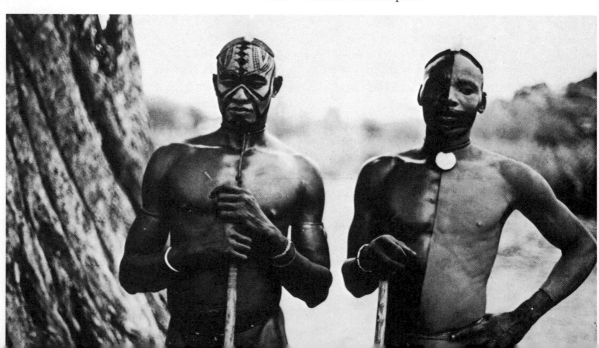

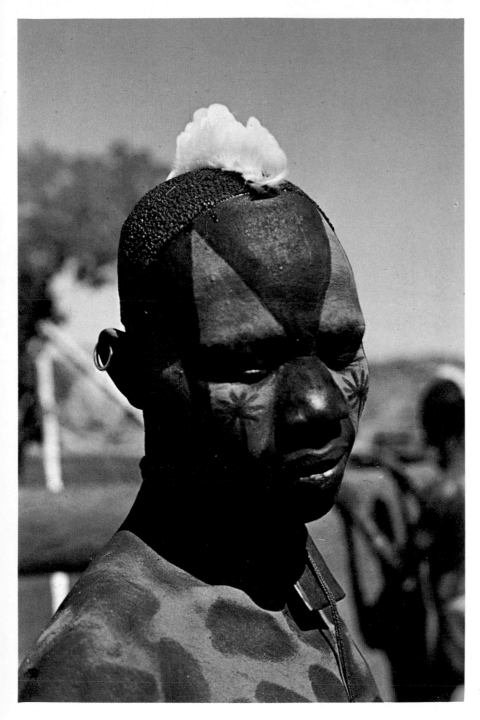

Colour plate 1
Kadūndōr youth with *dūn*
body design

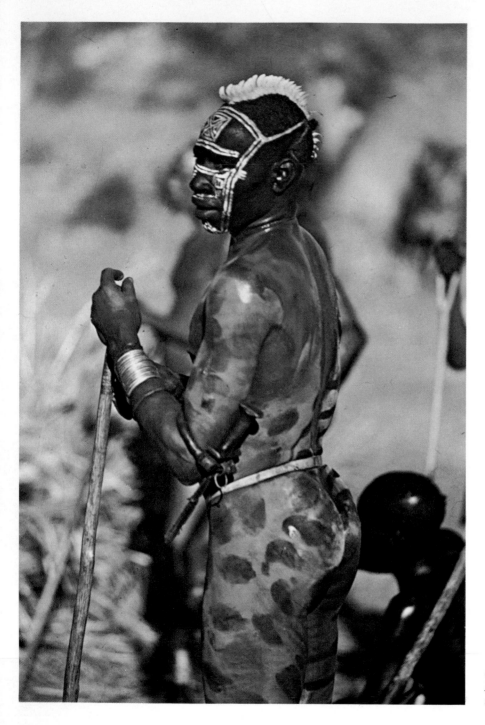

Colour plate 2
Kadūndōr with *krendelnya*
and *wēā kōra* body design

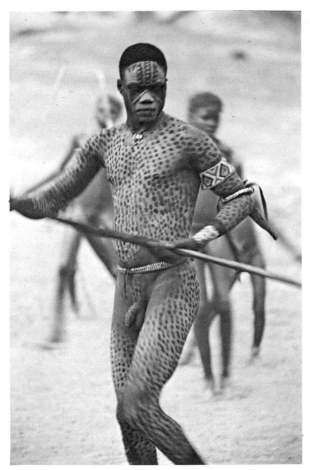

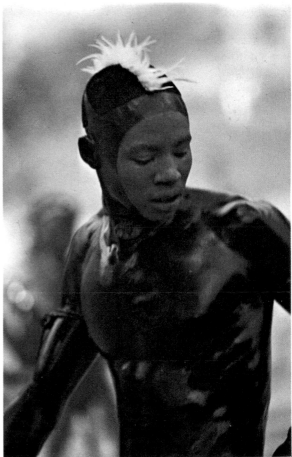

Colour plate 3
Kadūndōr with *tūrkā tera* body design prancing at
nyertuṇ dance

Colour plate 4
Wōtē wūṇin facial design, with total *gūmbā* body

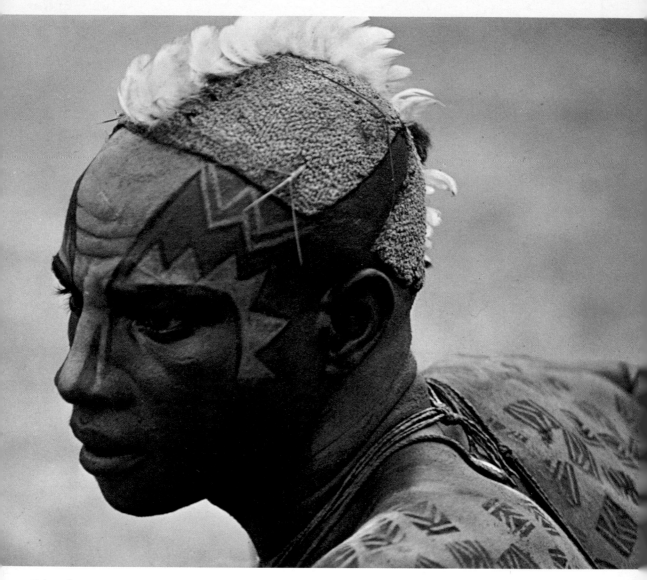

Colour plate 5
Non-representative body and facial design, stamped body design

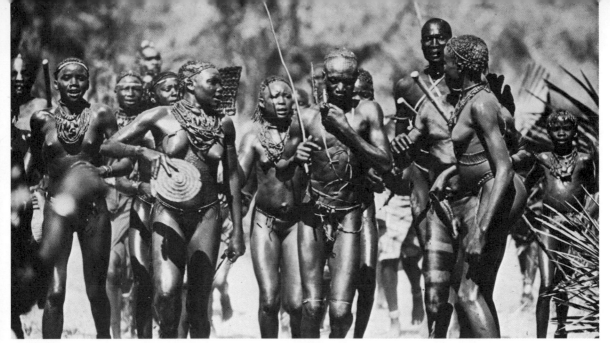

Plate 9
Lōeɲ youth returning from a long-distance race during the New Fruits ritual under escort of patrikinsmen. Note *ɲer* body design on the leg of the hidden figure on the right

Plate 10
Lōeɲ youth with asymmetrical non-representative facial design, requiring body motion for full aesthetic effect (see Pl. 11)

Plate 11
Right side of design in Pl. 10, illustrating asymmetry and the requirement of body motion as an aesthetic variable

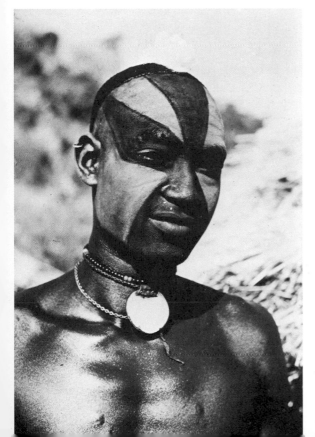

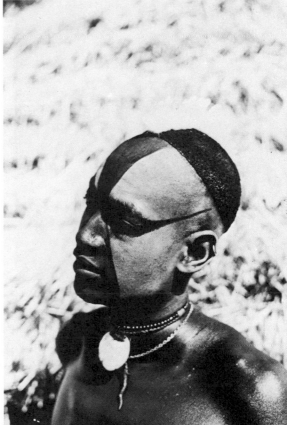

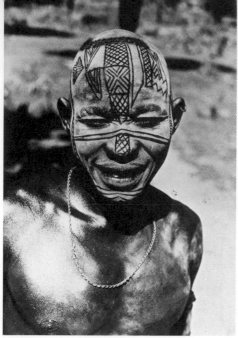

Plate 12
Facial design illustrating use of
contour in design. Note also the
flattening effect of the design across
the nose – an attempt to disguise a
nose considered too pointed

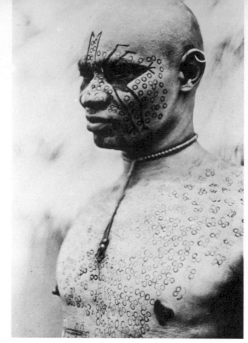

Plate 13
Daŋ ka fellata body design,
with *Type 1* whole-shape
morphology ostriches
over eyes

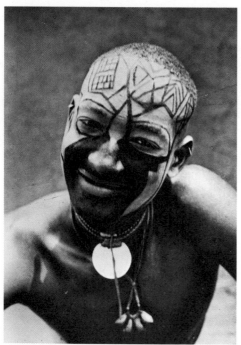

Plate 14
Lōeŗ youth with very
asymmetrical (yet
balanced) facial design

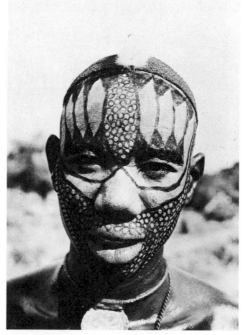

Plate 15
Typical *en face*
symmetrical facial design.
Note the lack of design
on back of cheek and jaw

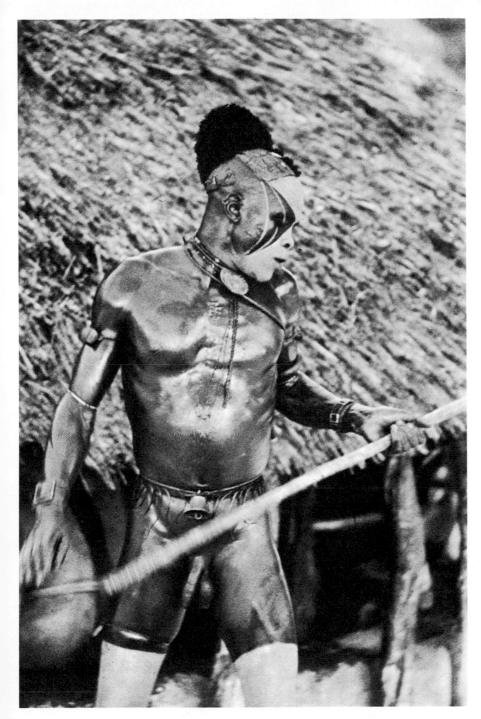

Plate 16
Cipaliṇ variation facial
design, *kūṇgūrū ka lelṛ*
body design

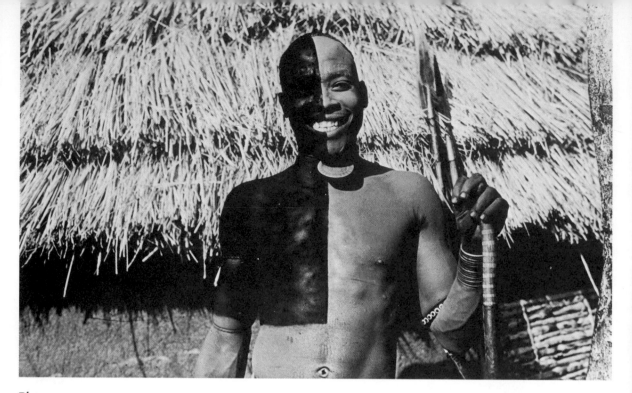

Plate 17
Modified *ţōrē* body design

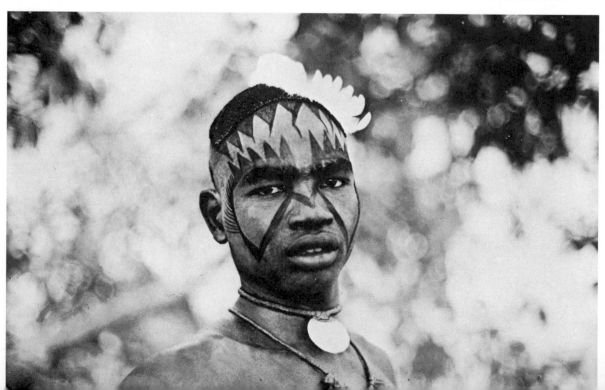

Plate 18
Slightly asymmetrical
facial design. Note the
feathers across the right
front of the hair

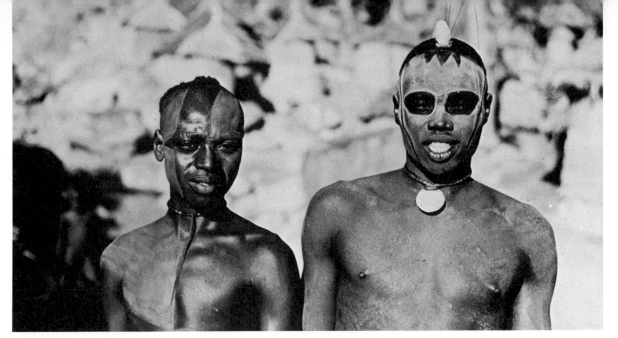

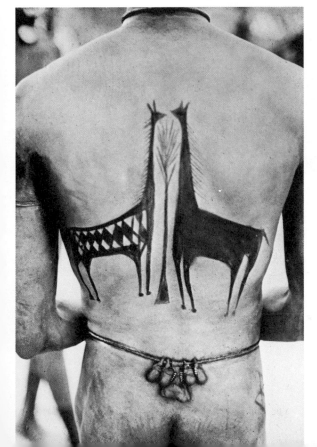

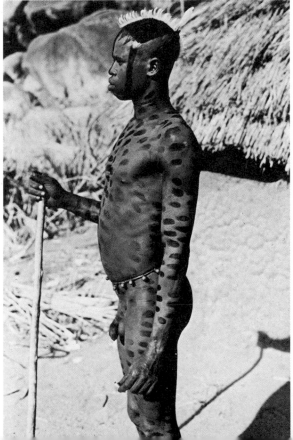

Plate 19
Vertically skewed asymmetry on the left *lōeʏ* facial design. The *lōeʏ* youth on the right has disguised eyes considered too small

Plate 20
Dūn Type 1 whole-shape morphology representations, male and female. The small pouches hanging off the belt contain protective herbs and roots

Plate 21
Kamūlaṇ whole body design

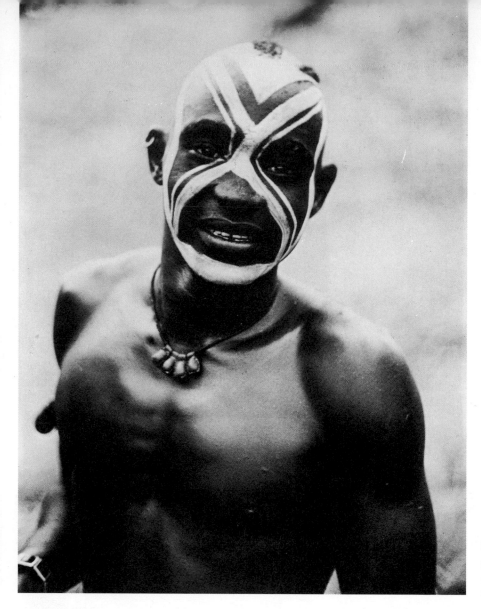

Plate 22
Typical symmetrical non-representational facial design, *nyūlaṇ* in type with radiation from nasal dip

as infants and children. Round the waist (see Col. pl. 15; Pls 20, 21), the neck (see Col. pls 1, 7, 18; Pls 6, 9, 14, 18, 22, 23, 24, 25), or the arm (see Col. pls 16, 26; Pls 2, 7, 17, 26) are commonly small pouches of leather which contain bits of herbs (*taō*) or some Arabic scribbling on a piece of paper (*kētab* – literally, 'book' [Arabic] – bought from Islamic *fakir* passing through Southeastern Nuba country), which are magical devices to insure success of several types, to protect against various things (from evil eye to snake bite), or to give added strength or power.

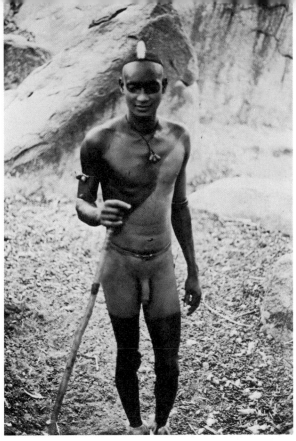

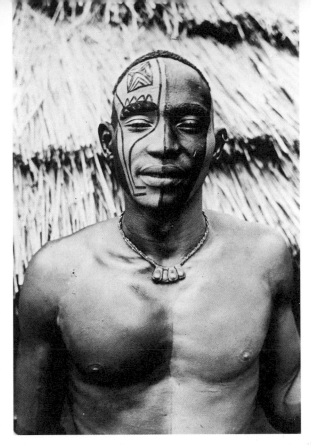

Plate 23
Nyūlaŋ design form type,
radiation from centre of
chest

Plate 24
Tōrē variation. The
balancing elements on left
side of face are
non-representational

Plate 25
Lōeṛ youth – all body designs *tōrē*,
all facial designs non-
representational, the centre facial
design asymmetrical

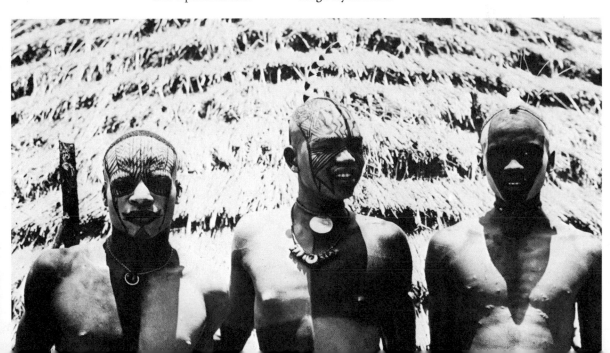

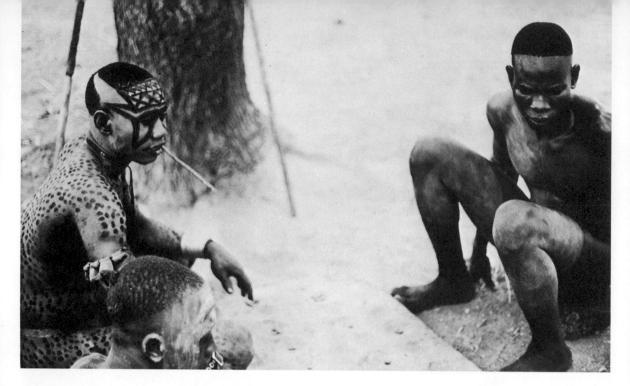

Only one item in this entire range of things worn is critical – for men and women, young and old alike. This is the belt (*kumbūŋ*), which may be made of almost any material, and which is considered essential to proper exposure. To be without this belt is to be naked and shameful.

Personal art is socially important to individuals right from birth. Normally a newborn child is rubbed with oil, and either red or yellow ochre is placed on its head around the area of the fontenelle – colour depending on its patriclan section membership.[18]

This oil and ochre head 'dressing' is maintained until the child is weaned. The mother covers her head and shoulders with oil and ochre until weaning – the colour of which also is peculiar to the infant's patriclan section, not her own. After about a month, and as soon as it has sufficient hair, the infant receives a hair cut which may be characteristic of its patriclan section (not all patriclan sections have characteristic infant hair fashions)[19] – see Fig. 2. And other patriclan sections require that their young children wear characteristic types of necklaces.

By the time a male child is eight or nine, and a female child is six or seven, a series of hair, colour, and scarification changes take place. At this time boys adopt a hair fashion – essentially a small skull cap (Fig. 2e, f) – and establish a small tuft of hair on their crown. This tuft, the *ṟūm*, will be maintained (even through several changes in hair style) until elderhood, and serves as a device to

Plate 26
Left body design, *tūrkā tera; kūŋgūrū ka lelṟ* on right (legs). Men playing a sixty-hole Shilluk seed game

30

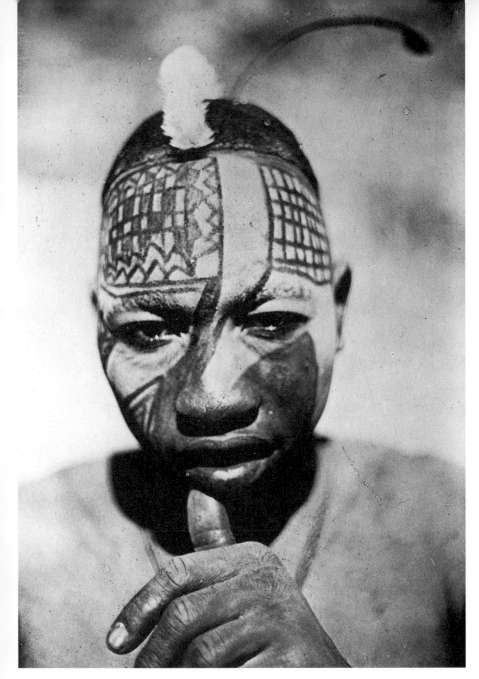

Plate 27
Asymmetrical facial
design, with careful
attention to balance – note
off-centre feathers along
sagittal crest

which to attach ostrich feathers and other decor (see Col. pls 11, 22, 26; Pls 16, 19, 21, 27).

Small girls of six or seven normally let their hair grow on the top of their head, shaving around the sides (Fig. 1a), and they begin to cover themselves daily

from head to toe in oil and either red or yellow ochre – the colour characterising their patriclan section membership (Col. pls 6, 7).

Each patriclan section has its own characteristic colour. The colours are either red or yellow, but since each clan section has a separate place from which to gather its ochre (haematite), there are slight differences between yellows and between reds which are ostensibly visible to members of the community (but see below, p. 61). The colours of the patriclans of the society are listed in Table 1. All brother sections (laŋ) of the same clan have similar (i.e., all red or all yellow) colours, and different clans sometimes share similar colours. In some cases this latter situation indicates reciprocal friendship, mutual aid and ritual relation‑ships (termed ɖaba) between them, and this will be articulated by people them‑selves. But historical circumstances have severed some of the ties, and thus it is not always the case that clans and sections of the same colour are linked in these ways.

TABLE 1: *Patriclans, sections and colours*

wā wa ēcēʔet		(yellow ochre)	wā wa wōr̥ē		(red ochre)
lɾōrā	–	(6 sections)	lɾemt̄ē	–	(2 sections)
lɾēor	–	(3 sections)	lɾkōra	–	(1 section)
lɾtōren	–	(4 sections)	lɾemēŋ	–	(2 sections)
lɾnyarō	–	(3 sections)			
lɾlam	–	(2 sections)			
lɾtebr	–	(1 section)			
lɾkūrēna	–	(1 section)			

Girls are under sanction not to change their colour, particularly along the red‑yellow axis.[20] If they do, a severe crippling disease (cūrḡa) is said to result, which particularly attacks the knees. I know of one girl who, because of the irritating effect of the yellow ferrous oxide on her skin, was allowed to wear red ferric oxide, even though it was not her patriclan section colour. The importance of being decorated here outweighed the sanctions against colour shift. In any other circumstance, however, cūrḡa may result from the misuse of colour.

The practice of total body colouring for girls continues until the beginning of pregnancy. Girls oil and apply ochre daily, particularly if a dance is coming, and to be without colour is to be not only improperly attired but also ritually removed from normal interaction (see below, p. 55).

Females, who do not have an elaborate age organisation like males, also begin a series of body scarifications at the age of nine or ten, which are rather closely related to physiological changes. The first of these (tūrar̥ē) is a series of scars cut on either side of the abdomen below the navel – joining above the naval and

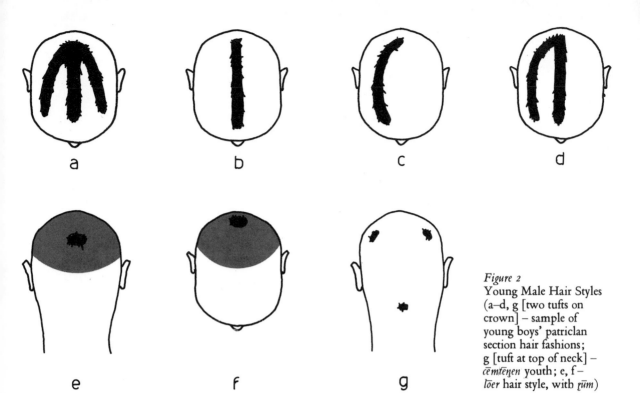

Figure 2
Young Male Hair Styles
(a–d, g [two tufts on
crown] – sample of
young boys' patriclan
section hair fashions;
g [tuft at top of neck] –
cḗmṭēṇen youth; e, f –
lõer hair style, with ṛ́um)

continuing to a point between the breasts (see Fig. 3a; Pl. 9 – girl in second row,
centre). These scars are made at the first signs of puberty as the breasts begin to
fill out. A second set (kaṛḗ) takes place after the start of menses. This is a series of
lateral parallel rows of scars under the breasts to the back over the entire length of
the torso (see Fig. 3b; Col. pls 6, 7; Pls 4, 9 – girl on left). This is the last scari-
fication until after the weaning of the first child, when a final scarring takes
place (ṛ́uṛṓla), all over the back, the neck, the back of the arms, buttocks, and
back of the legs to the knee (see Pls 3, 28).

All the scarrings except the last series after childbirth and weaning are done
free by the female cicatrisation specialist of the village section – though it is
expected that the girls will reciprocate with some aid in grinding grain, or with
a load or two of firewood. All scarring takes place on the mountainside above
each village section, for blood is extremely polluting, and must not be allowed
to come into contact with productive apparatus such as agricultural implements,
or cooking pots, or with weapons.

Scarring involves two instruments – a hooked thorn (wōṛ́a) with which the
skin is hooked and pulled up and a small blade (tembaḷā) with which the raised
skin is sliced, to produce a slightly protruding scar. The more the skin is pulled

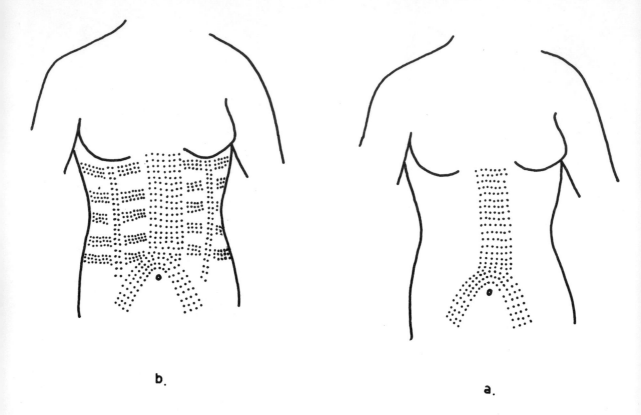

b.

a.

Figure 3
Pre-Marital Female
Cicatrisation
(a – *tūraɣē*, set of scars on
first indication of puberty;
b – *karē*, set of scars on
initial menses)

up before cutting, the more raised will be the resulting scar (see Pl. 4), and not only is this considered more attractive, but it also lasts longer – for a woman's scars wear down through time, so that when old, hardly more than a slight surface distinction is visible where each raised scar was formerly (Pl. 3).

The scarring of young girls takes only a short time, but the final set of scars up to two full days. During the period of isolation, while the scars heal, the girls wear no ochre or oil and remain on the mountainside. Some oil, red ochre and leaves of the *ūrē* tree may be rubbed into the wounds to serve as antiseptic, but this is not decor. After the scars heal (within four to five days for the final set), the girls resume oiling and the use of colouring, re-entering normal social life.

The final set of scars for young mothers upon the weaning of their first child is expensive – about £S1·500 in cash, produce, cloth or other items, which is paid to the female specialist who does the scarring. A woman's husband usually pays, though it is not the responsibility of any individual or group, and she may collect from several sources. One argument men may use to steal the wives of others is promises to pay for the final set of scars. Refusal by a husband to pay for

34

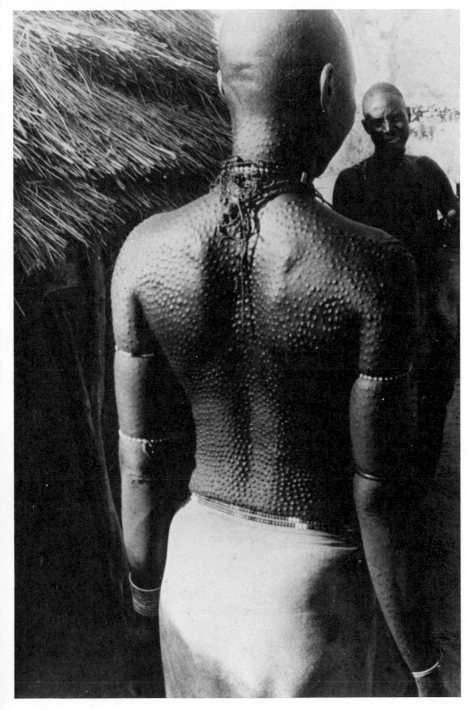

Plate 28
Final set of body scars
(ṛūrōla) given after
weaning of first child

his wife's final set of scars is tantamount to rejection, and it is anticipated that she may be stolen by another man.

A scarrer works quickly, an experienced specialist effecting about one scar per second. Work proceeds vertically or horizontally, with an occasional check to see that alignment is correct, wipe away blood, or allow the girl to rest. Naturally the task is painful to the girls, but they must bear it without complaint. In the final set, a woman may become faint, or even pass out from loss of blood and pain – though here, too, she is expected to remain stoical.

The chief sanctions upholding the scarring tradition centre on beauty. There is, however, a tradition that if a woman dies without having been scarred, a spirit scarrer will do the job before she entered after-life, and will use especially large and painful thorns.[21] The demands of beauty, however, appear to be more persuasive than supernatural sanctions. The only girls who do not undergo successive sets of scarrings are those with hereditary haemophilia-types of symptoms – whose wounds heal only after a long time and much loss of blood, and whose scars are large, septic and ugly. I know of six such individuals in the total society, three from the same family.

The final scarring, regarded primarily as a beauty treatment, also indicates a change of status, for a post-partum prohibition on sexual intercourse is observed until the child is weaned (see Faris, 1969a). This is explained as logically necessary, for the birth of two or three children in the same number of years puts too great a burden on a mother's milk supply, and affords each infant only a fraction of the milk regarded as sufficient. In a society which places so much emphasis (and reward) on the strong and healthy body, this materially based prohibition makes good sense. The final scarring, coming as it does on the weaning of a woman's first child,[22] is then a poignant re-introduction to an active sexual life – with an added measure of beauty. Wife theft is statistically most common at this time, as one might expect.

Boys undergo no series of body scarrings, but both males and females have facial scars – given them first about puberty, and repeated (and, for females, elaborated somewhat) again after a few years (see Fig. 1a, b). These too are principally for beauty, but cuts above the eyes are regarded also as aiding visual development and on the temples as inhibiting headache. Further decoration is never added to the scars themselves, in contrast to the custom among the Shilluk, where facial scars may be emphasised with colour (see Col. pl. 17).

Girls cease to wear oil and ochre on pregnancy, except to cover their heads and shoulders with oil and ochre (colour peculiar to their husband's patriclan section) while nursing infants. They take a skirt on pregnancy such as they will wear the rest of their lives (see Col. pls 8, 15; Pls 3, 28, 29).[23] The style of the skirt may change (and the cowrie belt with it), to signify physiological changes.

36

Plate 29
Ritual facial painting of women's singing society (*kāmā*) leader

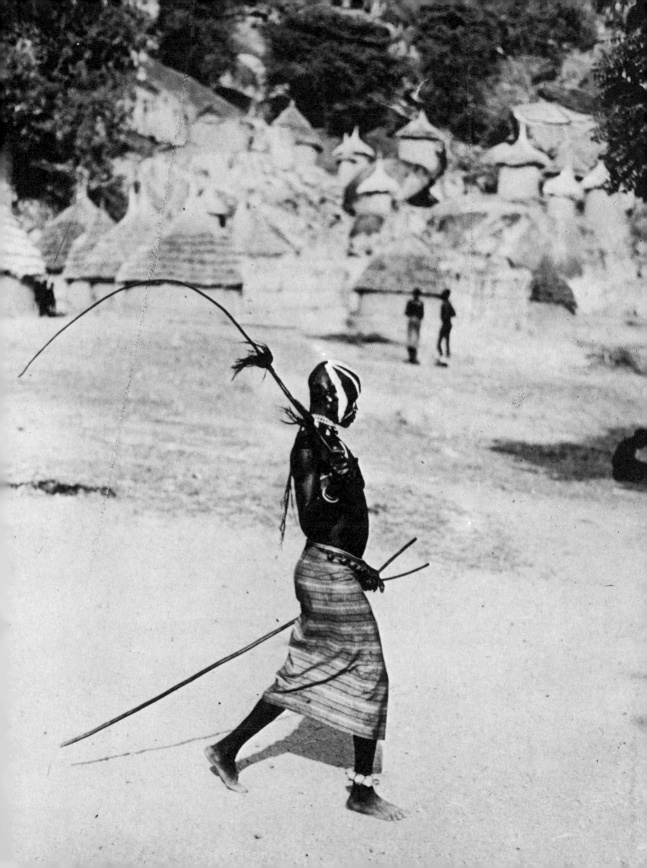

On menopause, for example, the cowrie belt style is shifted, and women begin to wear dark blue skirts (see Pl. 3), instead of the previous white or coloured variety (see Col. pls 8, 15; Pls 19, 28). On rare ritual occasions an adult female not nursing a child, or past childbearing, may apply facial painting. This is not at all common, however, and usually applies only to female ritual leaders, such as the leader of the women's singing society, the kāmā (see Pl. 29).

For males, the beginning of age organisation activity is the beginning of a series of diacritical stages marked by hair decoration and body painting (see Faris, 1971.) Table 2 outlines the age grades, their component age sets, and the various diacritical markers peculiar to each.

TABLE 2: *Southeastern Nuba age organisation*

Grade (no term)	set (lamē kaŋgern)	hair style	diacritical marks	approx. beginning age
I lōeṛ	1 cūr (fallen testicles)	small skull cap + ṛūm	use of red permitted	8–11
	2 bakabak (broad shouldered)	larger skull cap + ṛūm		11–14
	3 paṭera (large)	larger skull cap + ṛūm		14–17
II kadūndōr	1 ēya (new)	kadūndōr strips + ṛūm	use of yellow permitted	17–20
	2 krō ka tācō (children of the fighting stick)	kadūndōr strips + ṛūm		20–23
	3 krō tōrga (children in between)	kadūndōr strips + ṛūm		23–26
	4 krō kōren (old children)	kadūndōr strips + ṛūm	use of black permitted	26–29
	5 dāgenya (fathers)	kadūndōr strips + ṛūm		29–31
III kadōnga	1 ketlēŋ (little)	kadūndōr strips only		31–45
	2 kōren (old)	head shaved		45–

The age organisation is peculiar to males, and the three grades broadly designate particular productive activities. More conspicuously, the grades define tribal sport and organised competitive athletics. The initial grade, lōeṛ, is characterised by wrestling; the middle grade, kadūndōr, by bracelet and stick fighting; and the final grade, kadōnga, by retirement from active tribal sports.

As mentioned above, a young boy on becoming a member of the first age set, lōeṛ ka cūr, takes a hair style resembling a small skull cap (lūḍū) and begins to maintain a tuft of hair (ṛūm) on the crown of the head (Fig. 2e, f). He is also eligible at this time to begin simple inconspicuous decorating with red ochre and grey-white. Each set status lasts three years. During the second set of the lōeṛ grade,

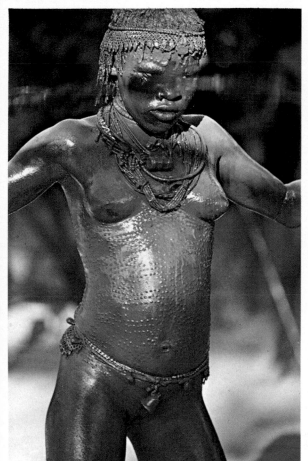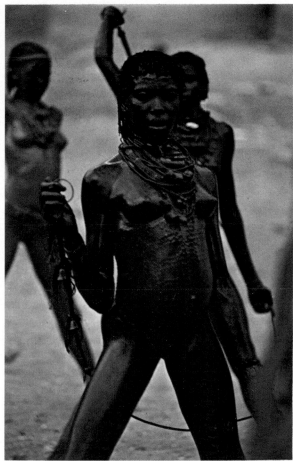

Colour plate 6
Nubile girl, covered with *wa wa ēcēʔēt*, at *nyertuṇ*
dance; *karē* scars

Colour plate 7
Nubile girl, covered with *wā wa wōṛē*, at *nyertuṇ*
dance; *karē* scars

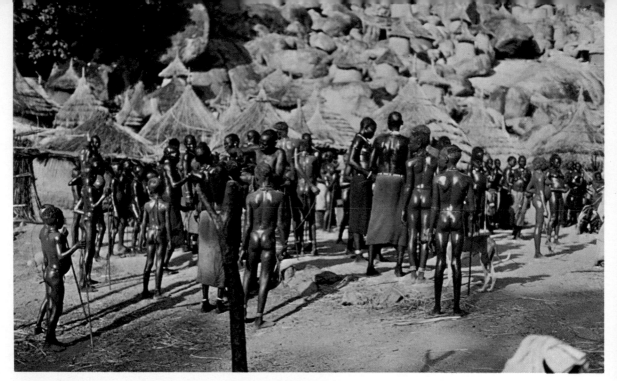

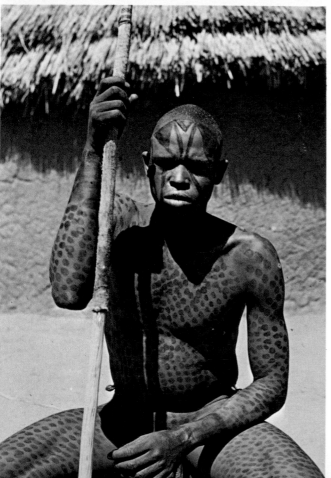

Colour plate 8
Young girls being oiled before a *nyertuṇ* dance by matrikinswomen and matrikinswomen of their betrothed

Colour plate 9
Kadūndōr with *tūrkā tōṟē* body design

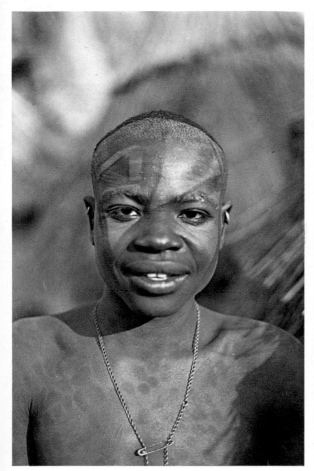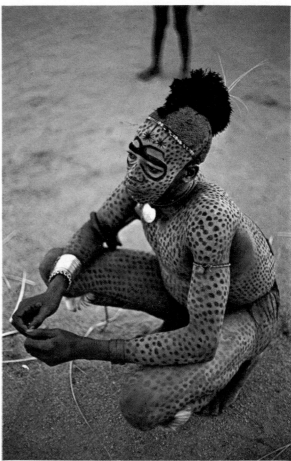

Colour plate 10
Lōeṛ youth with *kōkarō* body design and
asymmetrical facial design

Colour plate 11
Kadūndōr with *tūrkā tera* body design; ostrich
plume attached to *ṛūm*

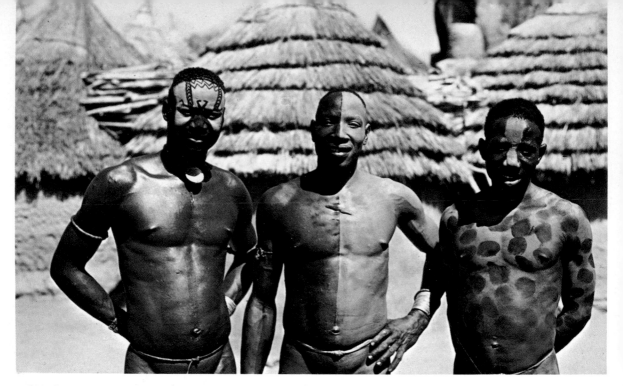

Colour plate 12
Orthodox *tōrē* body design on middle figure; *krendelnya* body design, *jaēṇ jaēṇ* facial design on right figure

Colour plate 13
Grain stacked before threshing. With seed grain on top and white grain arranged to protect against evil eye, this stack is one man's crop in a good year. The principal motivation for this stacking arrangement, however, is aesthetic

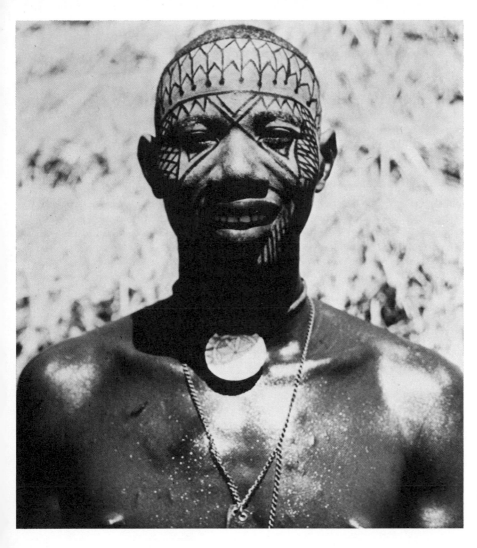

Plate 30
Non-representational
symmetrical facial design –
the forehead treated
separately from the lower
face

puberty is well on, and the skull-cap hair style becomes larger in circumference. By the end of the second (*bakabak*) set, or the beginning of the third and last set of the *lōeṛ* grade (*paṭera*), the skull cap reaches its maximum circumference (see Pls 10, 11 26), and the youths begin more elaborate and conspicious designs, for their bodies are now mature. In colour selection, only yellow and deep black (as background) are still unavailable to them, but they use red (*cōrda cōṛē*) for either design or background to design in black. Grey-white (*cōrda cera*) – see below, p. 62 for composition) is at this time used as background for designs in red or black, and other colours, such as blue (from *zhar*) purchased from Arab

39

merchants (see Col. pls 19, 25), and off-yellow (roughly orange) may also be used by older *lōey* boys. Some of the finest personal art is created by artists of the *lōey patena* (Col. pls 19, 25; Pls 6, 11, 15, 19, 25, 27, 30, 31). The boys have considerable time to spend between cattle-herding chores and brideservice obligations, and are anxious to show off their bodies – recently matured, firm and handsome. This freedom artistically is also encouraged by the fact that their sporting activity, wrestling, is seldom subject to the same ritual restrictions on art forms as characterise the more dangerous bracelet and stick fighting sport of the next grade (*kadūndōr*). With these latter sports, too flamboyant or elaborate a body design is considered to be dangerous, for it attracts the attention of indi-viduals – some of whom may be envious and thereby able to project harm to the artist. This works in a manner not unlike evil eye pollution.

Entry into the *kadūndōr* grade means a change of hair style and addition of colours for decoration, plus a new series of sanctions about body display, the use and type of decoration, and exposure, for the first time, to the use of ritual colour for various functions. There are many more cultural aspects associated with the personal art tradition from this time forward (see below, p. 47). Although the colours and rules of use differ, the design forms, styles and representations are the same as have been used previously.

On becoming a *kadūndōr ēya*, a young man is eligible to use the rich yellow (*cōrda alō*) in body decoration. He has used off-yellows and oranges before (see above, p. 38, and Col. pls 9, 10), but if this colouring had become too yellow – that is, too much like *cōrda alō* – elders would have chastised him, asking him if he was actually courting the crippling disease from improper colour use (*cūrgā*), or if he wished to attract evil eye (*cē cūcō*). It will be another two years, however, before he is eligible to use the rich black (*gūmbā*) in decorating (see Table 2 above), after the first dance-praise song is performed following his first bracelet fight. This will be in his third year of the *ēya* set, before advancement to the second set of the *kadūndōr* grade, *krō ka tācō*. After this, the society's full range of colours is available for decoration, though their use is appropriate only at certain times.

The rich deep black (*gūmbā*) is normally reserved for the bracelet fights as it makes the user look bigger to an opponent (see Col. pl. 23), or for the dance-praise songs (*nyertuŋ*) where a young man prances and exposes himself on hearing his praises sung. The rich black is also impermeable to *cē cūcō*, whereas a designed body is not. Other dark colours, such as brown from mud (or in special cases, and for particular patriclans – brown from the spores of the *dōŋeraŋ* mushroom), are sometimes used in the tribal sports – and are also impermeable to evil eye.

All *kadūndōr* involved in the fight, whatever their body design, dust their shoulders with dirt or mud, which comes from a sacred source. Each patriclan

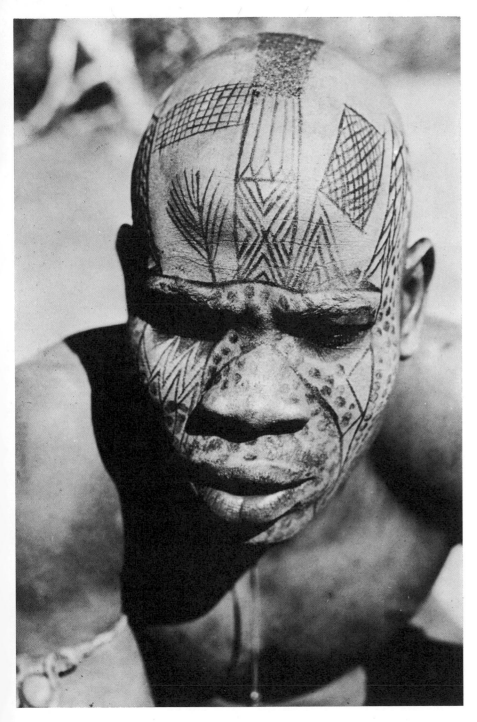

Plate 31
Asymmetrical, but well-
balanced facial design –
the center hair strip made
part of the design

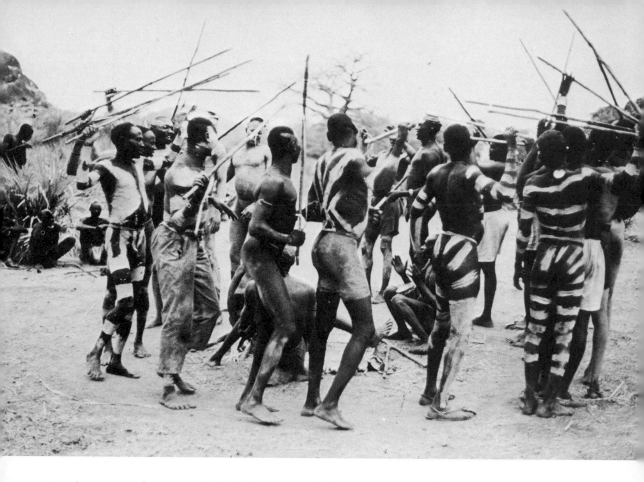

Plate 32
Cemţēņen ritual. Note the
ritual painting of talc
white on an un-oiled body

section (or group of reciprocally linked sections sharing the same men's hut –
tawō) has a small cave in the mountainside above the village section from which
it gets the sacred dirt (*kū*). This *kū* is protective, inhibiting blows from opponents.
Older fighters in their last years of *kadūndōr* grade may not use the sacred mud,
but it is a frequent component of body decor for most others at the bracelet and
stick fights.

At the *nyertuņ* praise-song dance *kadūndōr* attempt to look their finest, and to
have especially elaborate or well-executed designs – for here they prance and
preen on hearing their praises sung by the drummers' society (*cabaja* – see Faris,
1970, for details), and are recipients of considerable attention from the com-
munity, particularly from young females. One drum cadence of the praise-song
dance signals the nubile girls to enter the men's hut (*tawō*) where the young
fighters are seated to listen. Then, facing the young man, on another signal from
the drummer, they throw their legs over the shoulders of the seated *kadūndōr*. These
girls are all betrothed, but are not yet pregnant and their marriages have not yet
been consummated. Though mature, they are still covering themselves with oil

42

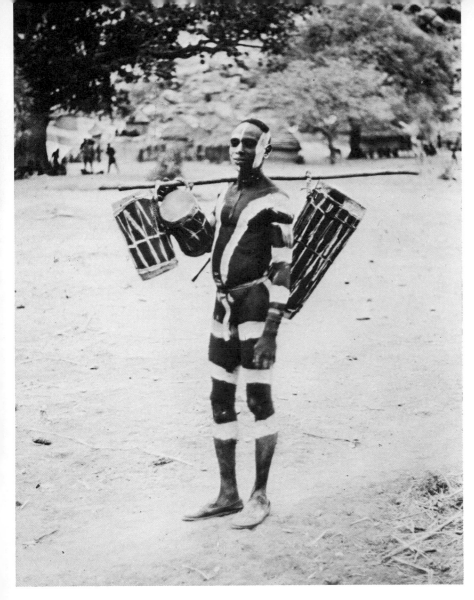

and ochre (see Col. pls 6, 7), and have not yet taken on the skirt characteristic
of married women. The choice of recipients for this action is left to the girls
themselves, though it is usually an especially brave or well-decorated fighter,
with whom they might wish to later have a rendezvous.

 Other occasions for specific body decor, for members of the *kadūndōr* age grade,
are ritual occasions. These involve the use, on some part or all of the body, of the
chalky talc white of ground limestone mixed with water. The ritual white may
be used in designs on the body (see Pls 29, 32, 33), or simply be smeared on the
body arbitrarily.[24] Oil is not used on the body in these situations – but simply the

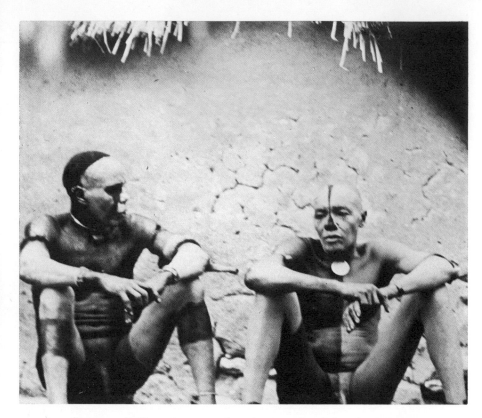

Plate 34
Kadōnga men still decorating. The man on the left has adopted the *lōeṛ* hair style

poorly adhering chalky-white on the clean and oil-free body surface. This colouring is used by important participants in funeral activities (*lōeṛ* boys, however close to the deceased, simply do not participate in the rituals involved), and in activities of the various ritual societies, such as at *cemṭēnen* (see Pls 32, 33).

On advancement to the final elder grade of the age organisation, *kadōnga*, secular body designing usually stops, but there is the greater frequency of ritual painting, as men are now in positions of ritual leadership and decision-making in the ritual societies and clan priesthoods. A few *kadōnga* may continue to decorate themselves (Pl. 34), but they are regarded as deviant. It is considered that when one becomes *kadōnga*, one's body is no longer pleasing to view – no longer firm and youthful – so why, it is asked, would anyone wish to call attention to it by decorating? Almost all old men, in fact, wear shorts or a loose Arab garment to cover their bodies (see below, p. 59). There are, however, no sanctions save ridicule, against those elders who continue to decorate themselves outside ritual contexts.

As mentioned above (p. 40), a new hair style characterises the *kadūndōr* grade. The skull-cap arrangement of *lōeṛ* is abandoned, as hair is grown over a wider

portion of the head – with two shaven strips running from the ṟūm to the face, at an ever-increasing width (see Col. pls 1, 2, 4, 5, 11, 16, 18). This hair arrangement does not change throughout the entire kadūndōr grade (the name of the grade, in fact, is the term by which the two shaved strips are labelled), and may be used by younger kadōnga – though on entry into the kadōnga grade the ṟūm is abandoned, for as they are no longer involved in the tribal sports or in the nyertuṇ dances, there is no need for a tuft for the attachment of ostrich plumes (see Col. pls 11, 22, 26) or feathers.

Kadūndōr hair styles, like lōeṟ, are groomed with wax (see below, p. 65, for details of hair grooming), or simply kept carefully trimmed (see Col. pl. 16). After several years in the kadōnga grade, the head is finally kept shaved. Priests may continue to wear special hair styles, peculiar to the priesthood, but all others cease to groom the hair. Occasionally members of one of the younger grades will shave their heads – usually to establish a new base after their hair has grown too long to arrange easily; but commonly, while waiting for the new growth, a 'hair' arrangement appropriate to the age grade is simply painted on the bald head (see Col. pl. 19).[25]

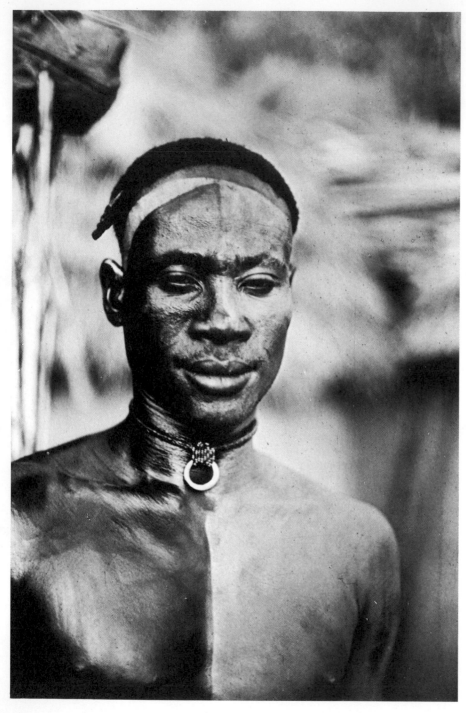

Plate 35
Asymmetrical variation
on the basic *ṭōrē* design

The cultural context

Apart from the way in which colour, hair style and body scarification indicate various social and physical statuses in the age organisation, in ritual participation and in clan membership – they are also of critical importance culturally.

It should be mentioned at the outset that Southeastern Nuba personal art is not a cosmological art – in the sense that various artistic forms are influential elsewhere – that various representations have totemic significance or serve to control in some way the representation (see Introduction, p. 6). A particular leopard design gives the wearer no power over the animal. Nor does the wearer attempt to simulate the behaviour of the animal. Nor is he enabled to partake of some particular quality of the animal. On the contrary, this would be difficult, as frequently an individual may have represented on him more than one animal or natural species at the same time (see Col. pls 2, 12 – man on right; Pls 13, 20, 36, 37 – seated figure in centre, and below, p. 80).

Various clans have certain plant and animal taboos, and also specific responsibility for ritual control of certain animals, plants and natural phenomena for the rest of the society (see Faris, 1968a), but this is not relevant to the personal art tradition. Young men of a clan section, for example, having ritual responsibility for control over forest monkeys, neither avoid nor particularly cultivate designs of this type of monkey. I was unable to discover any specific prohibition on the representation of any natural species. Even though poisonous snakes are feared, many of them have striking designs that figure commonly in personal art (see Fig. 4 and Pl. 38).

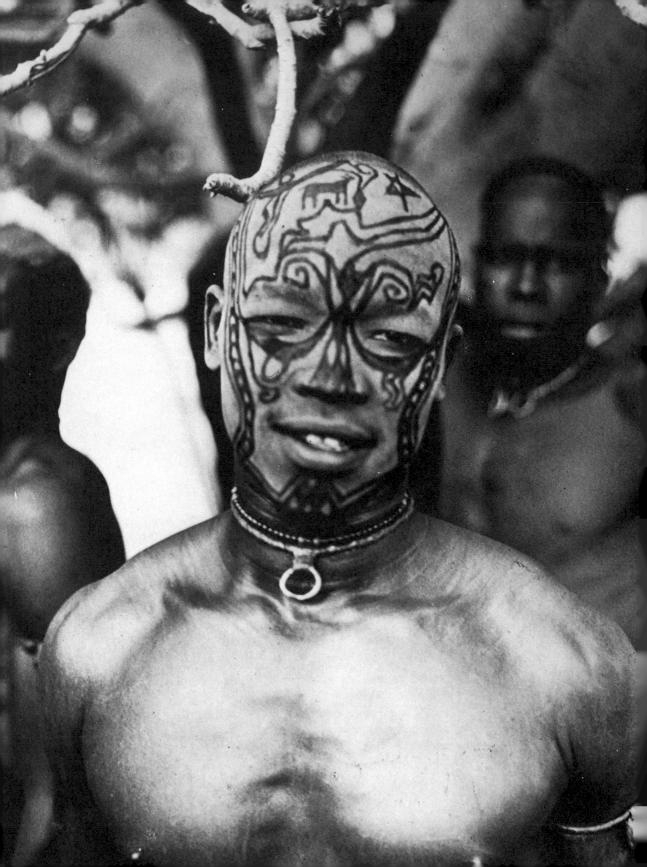

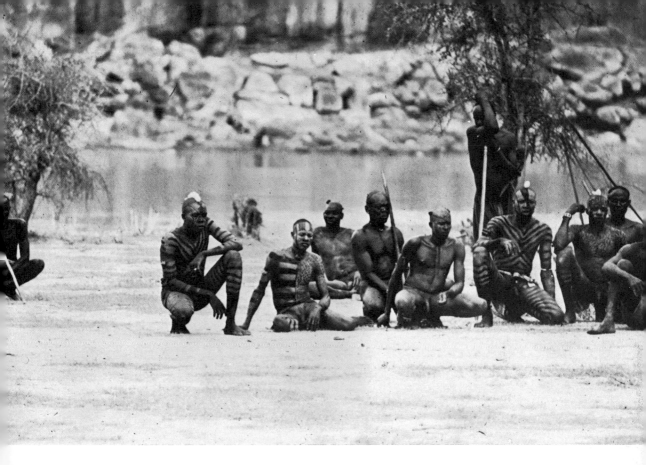

The major factor in the choice of natural species for representation is whether the surface morphology of the species appears aesthetically capable of, and worthy of, imitation (or non-iconic representation). The way in which many natural species are depicted is dictated by specific and precise rules (see Part Two), but original choice for assignment to the corpus of those whose representation is so formalised appears to be related to aesthetic appeal and codability.

The representations of various new forms, such as English word strings (see above, p. 19), depend on their appeal as design forms – forms with which to complement the body.[26] All personal art, then, is in this sense design, and the representational aspects of it are minimal, even for design forms which are clearly (iconically) representational. The primary function of the artistic exercise is not symbolic – the body is paramount to the representation. There is, in fact, no linguistic distinction between representative designs and non-representative designs. There are several terms for basic design styles and form types (see Table 6 and Fig. 6), but these all refer to the design as it relates to the body and is projected to the viewer, and these terms are not specific either to symbolic designs or

Plate 37
Several *tōmā* and *pacōrē* design form types. They are watching tribal sport

Plate 36
Asymmetrical facial design with curvilinear elements. Note *Type 1* whole shape morphology representations on the forehead, and the fading of the designs into *kadūndōr* strips

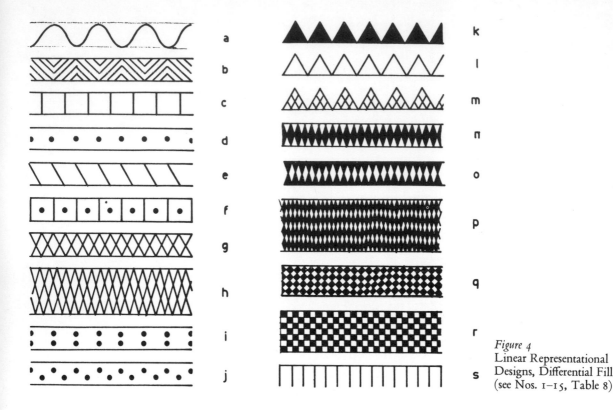

Figure 4
Linear Representational
Designs, Differential Fill
(see Nos. 1–15, Table 8)

to non-representational designs. The distinction I shall make between them is analytical. A foreign viewer could probably only know if he or she asked (or, if he or she learned the rules for codifying and generating the corpus of representational forms discussed below, chapter eight).[27]

For many other designs, of course, the whole morphology of the natural species is depicted, and the meaning of the design is obvious (the relationship between representation and object is iconic). But Southeastern Nuba personal art is not a semantic art in the sense that all design has some type of deeper symbolic meaning. The most meaningful element is the medium on which it is commonly produced – the human body.[28] This culturally proper exposure can be, perhaps, as Lévi-Strauss has suggested, the essential expression of culturological man as opposed to the biological individual (Lévi-Strauss, 1963a:259).

The repertory of natural forms available has been commented upon earlier (see above, p. 17). An examination of the cultural aspects of these natural species is not very revealing – that is, there is no particular unity in the forms culturally chosen for personal art. They are not, necessarily, 'thinkable' (Lévi-Strauss, 1963b), but rather are perceived as having a morphology in shape or surface

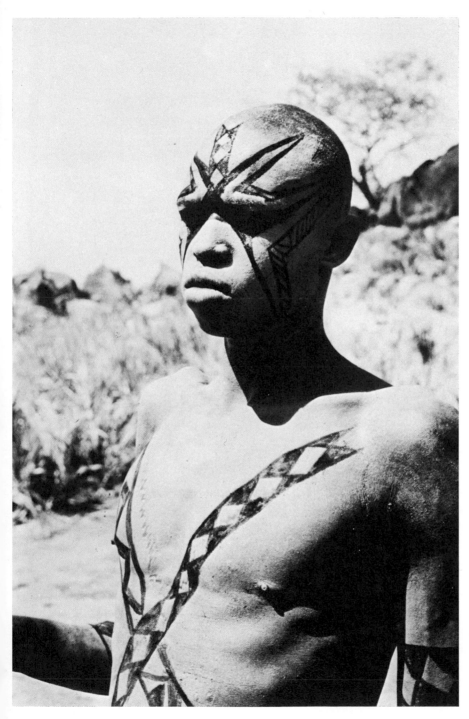

Plate 38
Nyūlaŋ design form types
– radiation from upper
abdomen and nasal dip.
These are both
representational and non-
representational linear
designs

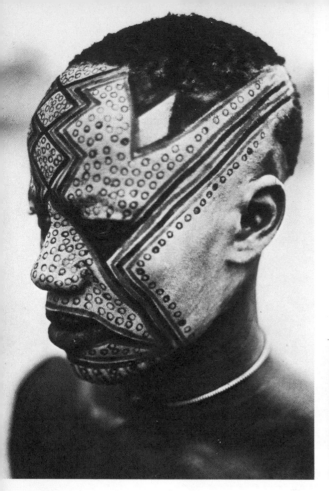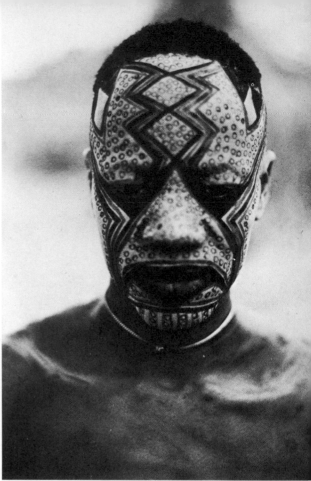

sufficiently pleasing, codable, and appropriate to be represented or duplicated on the body. In the universe of representational forms to be discussed, there is no juxtaposition of the representation with the object in the *semantic* sense, even if there is *iconic* deviation.

More important than the presentation of meaning of a representational design is the preservation of balance, or culturally acceptable asymmetry. The critical attributes necessary for a member of the culture to identify a representation are never obliterated, but they may be altered to allow for the play of culturo-aesthetic rules – rules of style and form which treat the body and its celebration as primary. Although they do not conflict, these aesthetic rules[29] are always primary to the semantic rules (i.e., the graphic componental definition of the representation) and are more general. For example, contour and the body in motion (see Col. pl. 2; Pls 10, 11, 23, 39, 40, 41) are not semantic variables (see Table 9), but they are very relevant aesthetically and representations may be altered slightly to accommodate aesthetically the body or face (see below, p. 81).

Plate 39
Symmetrical facial design in black and red on white. Note the use of eyes, mouth, nasal dip and *kadūndōr* strips in the construction of the design

Plate 40
Design of Pl. 39, *en face*

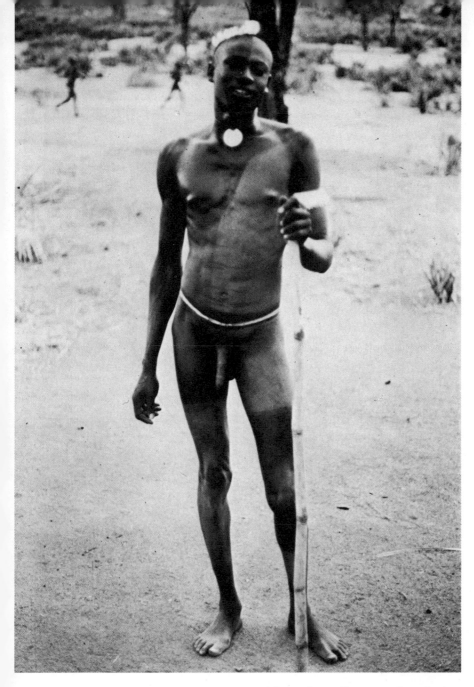

And certain colour contrasts are unacceptable aesthetically, even though they
might constitute possible semantic alternatives (for those representations whose
attribute definition involves any contrast between design colour and background
colour – see Table 8).

Colour symbolism, such as is reported to obtain in Central Africa (cf. Turner, 1966), is not found among the Southeastern Nuba. Colours do have a certain symbolic significance, and this is sometimes wide-ranging, but not people's every ritual action and classification is symbolised in colour. Moreover, a colour can be symbolic of one expression, such as evil, in one context, and its opposite in another. A deep rich black is regarded as the appropriate, beautiful and sought-after colour of the body – yet it can be the colour used to characterise a witch – kūṇinōrētuʔul (lit., 'black headed'). White, which is considered ugly and repulsive in the context of one's skin colour, and which symbolises in other situations a state of ritual removal, of abnormal and even non-human activity and structural position (see above, p. 43), is the colour used to characterize a good person – keraōrēpōʔōk (lit., 'white headed').

A witch can also be characterised as red, and there is avoidance of blood from *any* source (see Faris, 1969a). But red as a body colour is considered attractive. If a person's natural skin colour cannot be black, it is considered next most attractive to be red (rather than brown or white). Sorcery is described in black-white terms (bad-good, respectively), and this applies to the whole of a person's deeds and use of talents – white for good, black for evil.

To expand these symbolic statements, however, to the personal art tradition would be a mistake and to seek subliminal meanings either in colour use or in design elements is speculative (see Fig. 14 and p. 99). My queries regarding colour symbolism were thorough, and I must conclude that Southeastern Nuba colours and colour terms are polysemic – they are highly codable symbols and bear a large meaning capacity (see Colby, 1963 : 275 for a discussion of the codability of these types of signals) – but do not exhibit the range of all polysemic contrasts and relationships in individual contexts.

Other general cultural factors are important if we are to understand the emphasis on the prepared body in Southeastern Nuba personal art. I commented above on the fact that decorating ceases when males enter the elder kadōnga grade. This is because their bodies are no longer considered firm, young and attractive to look at, and in fact they normally begin to wear clothing at this time. This attitude towards exposure of the attractive body pervades the entire society, however, so that men of any age who are sick or injured, or whose bodies are otherwise incapacitated, will wear clothing or some type of cover for the duration of the illness or until the injury heals.

Moreover, the healthy body must be clean, shaved and oiled before it is considered appropriate for decorated exposure. I will consider hair symbolism shortly. Suffice it to say here that should a young man not find time to shave facial or pubic hair, he will not decorate, and may wear shorts until he finds time to shave. Relevant here, of course, is the fact that oil and colouring

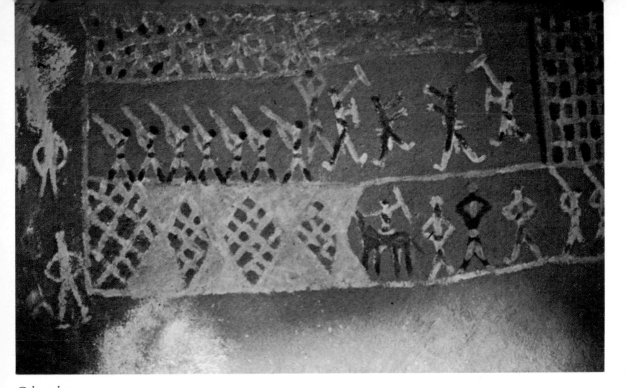

Colour plate 14
Mural on hut interior. Unlike body painting,
this depicts action scenes

Colour plate 15
Ritual re-oiling and re-ochreing after mourning
period – girls of patriclan sections linked to that
of deceased participating

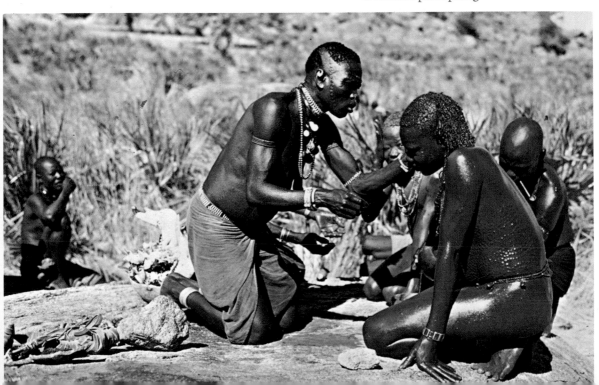

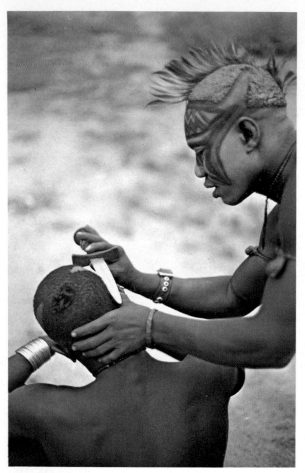
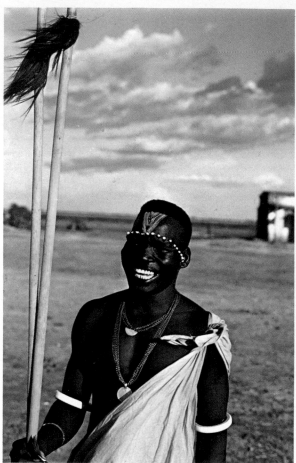

Colour plate 16
Hair cutting and grooming, *kadūndōr* hair style

Colour plate 17
Young Shilluk man, with decorated facial scars
(see Pl. 2)

material will simply not adhere properly, nor can detailed designs be executed, on a body or face with hair.

Oil is also considered critical for proper decorating and is important in other cultural domains, which helps make clear its significance to the art tradition. Decorating is impossible without oil, and since to be without oil is to be essentially naked, shorts or a loose Arab tunic will be worn until it can be acquired again. Colour background is always dusted over an oily surface, and designs will not adhere without the oil base. This is in contrast to Nilotic body painting and to ritual painting among the Southeastern Nuba (see Col. pl. 17 and Pls 29, 32, 33). Oil is necessary to help the skin surface appear black, for without oil the skin surface can become dry and flaky – giving a lighter (whiter) appearance – a colour condition considered especially unattractive. It is not without significance that talc white is involved in funeral ritual and other circumstances of ritual removal (applied to the body without oil).

Oil is an important feature of rites of passage, and the culturally normal and proper state in which to be is to be oiled (whether decorated or not). In various periods of ritual isolation, such as during initiations, funerals, and childbirth, participants in the activities do not oil themselves. But on re-entering society after the period of withdrawal, a symbolic oiling takes place – a formal and poignant indication of return to the proper cultural condition (see Col. pl. 15, an oiling of girls of linked patriclan sections following the final funeral ceremonies).

Young men in brideservice (there is no bridewealth among the Southeastern Nuba – only an extended period of brideservice – see Faris, 1969a) are required to furnish their betrothed with oil and ochre for daily decoration. And their failure to do so constitutes immediate grounds for severing the relationship and betrothal to another. Oil is also one of the single items frequently demanded as gifts by the young man's future affines. If a girl does not have oil, she will not venture from her hut – just as if she were confined for sickness (when she would also wear no oil).

Oil is considered the appropriate gift for all occasions, and is used extensively in hospitality. Many payments for services (as for the drummers at a death commemoration ceremony) or ritual performances (as for a curer to remove *taō* [herbs] from a person) must be partially in oil. It is appropriate behaviour when a guest arrives, particularly from one of the other two villages of the society, for the host to offer oil to the male guests to put on, or to help oil the female guests.

Oil is, moreover, applied to wounds, swellings, bites, and is drunk for good health and fitness. And for especially important guests, or at times of community feast, oil is poured into beer to enhance its flavour.

The significance of proper hair grooming extends all the way to the definition of the human species. Hair grooming, the ability to remove hair, and smooth

bodies are all characteristics of humans – characteristics not all shared by animals. It is not language (which monkeys, in Southeastern Nuba myths, once shared with man), but shaving – the *choice* to have or not to have hair – that distinguishes humans from other 'moving species' (*lēmūyā* – as Southeastern Nuba classificatory schemes gloss both men and animals).

The symbolism surrounding hair extends further. For a period of the year during the rains, some village sections (particularly of Kao and Fungor) move to far farm sites – some two to three hours from the village – where they stay until the grain is ripe. This arrangement is not liked, and people regard the time at the far farms as undesirable, and in essence uncivilised. They do not decorate, oil, or shave while at the far farms[30] – a powerful reminder that they are outside the centre of human concern, the village, and, like animals, occupy homes in the savanna forest. On coming back to the village, shaving, grooming and oiling begins immediately.

Ritual attention to hair grooming extends even to the dead (see p. 118, n. 21 for other ritual 'grooming' attention to the dead in circumcision practice). Some time after a death (from three or four months to two years) the kinsmen of the deceased (this is a matriclan responsibility, but aid is commonly sought from the deceased's patrikinsmen as well) are obliged to hold death commemoration ceremonies (*lṛū*) in order that the spirit of the deceased be settled in the after-life (see Faris, 1968a). The spirit of the deceased for whom this ritual has not been held can become restless and troublesome – causing crop failure, unsuccessful hunts or persistent illnesses – so that even though the ceremonies are extremely expensive (involving all-night drumming and beer for participants and guests), the living kinsmen are obliged to perform the ceremony. The fact essential to the present study is that the death commemoration ceremonies are a type of ritual 'hair grooming' necessary for the spirit of the deceased to stop wandering like an animal in the forest, and be accepted, 'properly groomed', into the after-life community. Hence the name of the ceremonies, which initially appears so puzzling, *lṛū* ('hair of the head').[31]

Loose hair can be dangerous, as in many other societies, and people normally take care to bury body or facial hair which has been shaved off, just as they will cover blood from a simple everyday cut. If loose hair is accidentally stepped on, it is acknowledged that misfortune may result. Persons are chastised if they do not dispose of hair they have shaved. There are no restrictions about cutting, however, and any friend or kinsman can aid in hair cutting (see Col. pl. 16). If an enemy acquires some of a person's hair, however, he may be able to effect various magic (sorcery) to lose him in the forest or otherwise bring him misfortune.

Certain persons of the society cannot be attacked by witchcraft – or rather, they

are sufficiently 'powerful' themselves to ward off the attack, the only visible result being cracking of their fingernails or loss of hair. Hair is thus the most vulnerable part of the body, the most easily attacked. Grooming is *control* over this material – a cultural act and a manifestation of humanity, just as supernatural attack, mentioned here – or in the sorcerer's use of some of a victim's hair – is also *control* and a clear cultural manifestation. Hair is part – and yet not part – of humans, and control, physically and supernaturally, is a supremely cultural act. Persons temporarily outside normal society (at the far farms or through illness) cease to groom and control – rejecting, temporarily, aspects of cultural status.

CHAPTER FIVE

Materials, techniques, anatomies and artists

OIL (*ŋera*)

The necessity and socio-cultural significance of oil has already been pointed out. All body decoration, male and female, requires an oil base – except for the limestone talc-and-water white used ritually, and the mud or sacred dirt which young men may smear on themselves before a bracelet and stick fight. Formerly all oil either came from animal fats (the term *ŋera*, may be glossed 'fat'), particularly pig (*kūder*), or, more commonly, was pressed from roasted sesame seeds (*nyergēt*). Today sesame is still an important source of oil for body decoration, but a more important supply is the oil (from cotton seed and peanuts) available from itinerant Arab merchants, and occasionally at a small Arab settlement, Iskut, at about an equal distance from each of the three villages; or most commonly, at the nearest market-town, Kologi, forty-five miles northwest (see Map). Here it is bought by the four-gallon tin – the price for which in 1969 was £S2.500 per tin. Purchasers of this amount sell small portions in turn to others in the local community.

People (male and female) normally oil both morning and evening, whether or not further decoration is intended, and whether or not the oil obliterates a previously executed design. In the cold season, of course, oiling is an important factor in keeping warm. Oil (with whatever decoration may exist) is removed by mixing up mud and smearing it on the body. This mud is left a few minutes to soak up the oil and colouring matter, and then rinsed off.

For young men, if a design is smeared soon after application, or if in the same

day they decide to apply another design, they may simply smear the previous design until the body is a uniform blended colour, and then apply more oil, a new background colour, and begin the new design.

COLOUR

The Southeastern Nuba have a system of colour terminology based essentially about an axis of four basic colour dimensions. They can specify many other colours or have terms which are the same as the label of the object so coloured. All colours can, however, be accommodated in the set of four basic colour terms.

Often, if a colour distinction is required for which there is not a basic colour term (such as the distinction between blue and black – see Table 3), the Southeastern Nuba will use the Arabic term for blue. The local term which covers both the areas covered by English blue and English black, has as its focal or type reference, the area covered by English black. The same procedure is used in borrowing from other terms of Arabic colour vocabulary – an elaborate vocabulary with many discriminating terms not used in the Southeastern Nuba terminology (or for colours which in local terms must be specified in lexically complex ways or which are noted by object labels). That is, in every case where Arabic terms are used to supplement local colour terminology, the terms chosen are appropriate for colour points which are not focal referents for the local colour terms. If the four basic colour terms are translated by the focal colours to which they refer, the terms are black, white, red, and yellow. The term translated black also applies to blue, dark purple, dark red, brown and other shades of low brilliance. The term translated 'white' is confined to colours of very high brilliance – extremely light blues, pinks, yellow, greens, and all off-white shades. 'Red' covers orange, pink, and all shades of red. And the term I translate as 'yellow' refers to practically all greens, blue-greens and yellows.[32] This may be illustrated in Table 3.

If the focal colour is to be emphasised, a suffix may be added, and if the quality of the focal colour is particularly striking or strong, the added suffix is strongly emphasised – after holding slightly the syllable before the stop (see Table 3).

A host of other terms occur which are descriptive of colour or colour conditions, many of which actually label objects. *Alō*, for example, is the name not only of the shade of yellow used by young men of *kadūndōr* age, but also of the material (a ferrous oxide) used for the colour – of a slightly different shade from the colour labelled *ēcēʔēt*.

Surface texture is coded, in the same lexical domain as colour terms themselves. An iridescent bird's wing, or a piece of metal, will be described as

59

kablēŋblēŋ – a term denoting the shiny surface, as well as perhaps 'suggesting' it in sound.

TABLE 3: *Southeastern Nuba primary colours*[33]

Term	English gloss (and term for focal colour)	suffix for focal colour	range of colours covered
1 *kūŋin*	'black'	-tūʔūl	black, v. dark red, brown, purple, blue
2 *kera*	'white'	-pōʔōk	v. light blues, greens, pinks and greys, whites
3 *ōr̯ē*	'red'	-piṭʔḍir	pink, orange, all medium shades of red
4 *ēcē*	'yellow'	-ʔēt	greens, yellows, blue-greens, yellow-greens

There is no term which can be translated 'colour', so that it is difficult to elicit colour categories. In asking the colour of newly cut *dom* palm leaves, I was told *tūtō*, and on asking a few days later when they had dried and whitened considerably, I was told *kwin*. Only later did I discover that I had been told that the 'colours' were 'crisp' and 'hardened' (like bone), respectively – and that the colour of both fresh and dried *dom* leaves was *ēcēʔēt*. In asking for the colour of some young bulls, I was told that one (red and white) was *atōlō*, another (all black with a small patch of reddish-white hair on the shoulders) was *deber̯lēn*. Later I learned I had been told 'spotted' and 'lightning', respectively (the latter being used because it described a light patch in a field of darkness).

Terms may be put together or added to other terms to describe more precisely the colour or surface condition of an object. *Kūŋin* and *kera* are used in situations which require 'dark' and 'light' labels respectively – where hue is irrelevant. Water for example, is not usually described by the colour it reflects, but by its brilliance – either *kūŋin* or *kera*.

The basic four colour terms are also the axes along which colours are most significant for decorating – and it is about the uses of these four that social rules pertain (see above, p. 39), and about which, as may be seen below, semantic distinctions are made in representational designs (see p. 101). Colour symbolism is of little significance in decorative art, and its limited application has been considered.

Most colouring material today comes from the site west of the village of Kao,

tē taka wā (see above, p. 14). Formerly each patriclan section had its own locus for red and yellow colours for its female members. Today, however, this is no longer maintained, and almost all colouring matter comes from the *tē taka wā* (lit., 'hole of the haematite'). This site – a large depression and cave with several tunnels and passages resulting from many years of excavating – is an iron ore deposit not unlike many others in southern Kordofan. The ore is primarily yellow ferrous oxide, which is today heated by girls of the 'red' patriclan sections to oxidise it to the red ferric oxide state. This oxidation results in a darker red than the red ferric oxide acquired naturally and which they formerly sought, but the plentiful supply and ease of access make this source of yellow ochre the locus of materials today also for girls of the 'red' patriclan sections.

The yellow colouring matter for males is taken from a different passage at the *tē taka wā* than for girls, and thus the colour is slightly different (rather less dark than the female source) and both material and colour are known by the term *alō*. For girls it is called *wā wa ēcēʔēt* (on heating, becoming *wā wa wōrè*). Although it is the obligation of betrothed to provide ochre for their brides-to-be, frequently girls and boys go to *tē taka ūa* together to escape the eyes of guardians and adults of the village.

Talc white is a chalky limestone acquired also from a site west of the village of Kao, and another critical element in the grey-white background colour of many designs – freshwater clam shells (*cēmē*) – is obtained from stream beds in the nearby savanna forest.

The body decoration material of males is termed *cōrda*, with the appropriate colour term affixed: *cōrda cera* (grey-white background colouring); *cōrda cōṛē* (red background colouring); *cōrda calō* (yellow background colouring); *cōrda cūṇin* (black background colouring). As may be seen (see Col. pls 9, 10, 22), colour combinations frequently result from a mixing of these basic materials. For girls, of course, there is only *wā wa wōṛē* (girl's red colouring) or *wā wa ēcē ʔēt* (girl's yellow colouring). And the talc white used alone by men *or* women only on ritual occasions (and without oil) – is labelled *tallō* (see Table 4).

Girls grind up the ochre lumps very finely, mix them with oil, and then rub this all over themselves, having another help them with areas they cannot reach (see Col. pls 6, 7). They may then (if it is available in sufficient quantities or before an important dance – see Col. pl. 8) simply pour oil over the oil-colour mixture, so that a fresh red or yellow gloss-enamel appearance results.

Males apply oil to their bodies first, rub it in well, then slap on the ground colouring material which will form the body colour (or background for a design) taking care not to mix it with the oil. It may take several slapping applications before a smooth solid colour results (see Col. pl. 20), but once on, it is more substantial than it might appear. The oil acts to hold the colouring

TABLE 4: *Colouring material: composition and source*

Term	sex of user	English gloss	composition	origin
1 cōrda cera	M	grey-white background	tallō (talc or chalky limestone) plus cēmē (ground freshwater clam shells)	limestone butte southwest of Kao, and in stream-beds of nearby forest
2 cōrda cūṇin	M	black background	gūmbā – ash of Dead Sea apple (kōpūl), or other woods leaving black ash	all species used plentiful and easily available
3 cōrda calō	M	yellow background	iron ochre (ferrous oxide)	tē taka wā (lower corridors)
4 cōrda cōṛē	M	red background	iron ochre (ferric oxide)	oxidation by heating of cōrda calō
5 wā wa ēcēʔēt	F	yellow colouring	iron ochre (ferrous oxide)	tē taka wā (upper corridors)
6 wā wa wōṛē	F	red colouring	iron ochre (ferric oxide)	oxidation by heating of wā wa ēcēʔēt
7 tallō	M or F	chalky white, used only ritually	talc – limestone	limestone butte southeast of Kao
8 zhar (Arabic)	M	blue	commercial blueing	Arab merchants

matter to the body – but only if the colouring matter is on in sufficient quantities; otherwise it is absorbed, thereby losing the dull-matt finish desired. Sometimes, particularly with the rich *gūmbā* (black – see Col. pl. 23), and when no further design is intended, young men will mix the oil and colouring to give an enamelled appearance (Col. pls 19, 22; Pl. 16).

If design is to be added to the dull-matt finish, it will be executed with small bits of grass dipped into the contrasting colour, or the fingers or hands dipped into the contrasting colour dust (fingers are used in the stripe and spot designs, see below, p. 67). Designs can also be produced with small carved stamps which are dipped into the colouring material and stamped on the body (see Col. pl. 5; Pls 13, 42). As mentioned, designs on the face are applied with the aid of small mirrors, and one's back is designed by a friend – usually an age mate from the same village section with whom one normally decorates.

If properly applied, a young man's design may last two days if he is careful, and a girl may have to re-oil and ochre only every other day. *Lōeṭ* youth – the society's most flamboyant decorators – will usually have a new design each day, a design which may take them up to an hour to accomplish. If girls from other

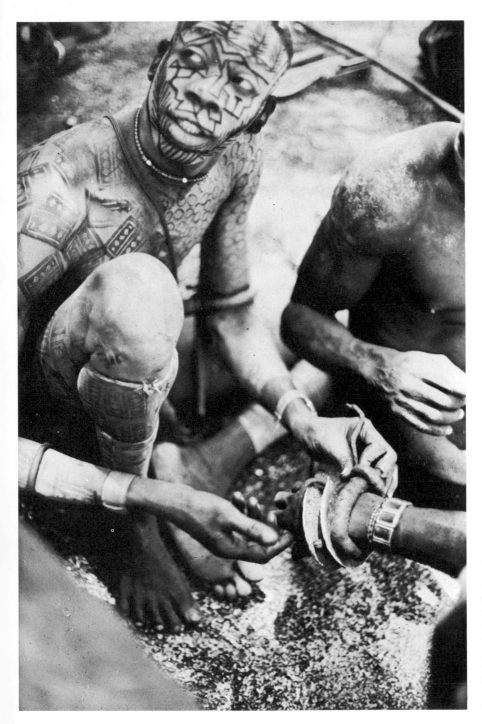

Plate 42
Tōmā design form type,
executed in *tōrē* fashion on
the body. The left side is a
non-representational
stamped design; the right
side exhibits a *tōmā*
representation. Note the
elaborate asymmetrical
facial design. The people
are securing brass bracelets
for bracelet fighting

villages are visiting, or if an important dance is pending, they may decorate and design twice in the same day. These young men will avoid brushing against people or things (and certainly avoid wrestling – the sport characterising their age grade) if they have just finished an elaborate design, and sleep only in a single position to minimise the body surface on the sleeping rack. In order to protect the elaborate hair decor (see below), they must sleep with their necks on the edge of the sleeping rack – their heads suspended the entire time.

Girls, of course, do not have to worry about smearing – only that the oil and ochre mixture will rub off. They have their own sleeping racks which, of course, drip with oil and colouring material. There are a series of regulations about just who may and who may not sit upon these sleeping racks (see Faris, 1969a: 485 ff.), and of course any offender immediately bears public mark of his or her breach. Boys who have been playing sexually with girls (particularly those visiting the other villages – to play in one's own village can be dangerous, for all girls are by this time betrothed) bear mark of it – and may be teased or envied, according to the circumstances. Jokes are told about young men who will put *wā wa wōr̥ē* or *wā wa ēcē ʔēt* on themselves to suggest to others that they have been successful in getting female attention (the red on left shoulder of the artist in Col. pl. 24 is from the leg of a female admirer).

HAIR

Hair decoration is also elaborate (or head decoration, if the hair has been shaved off – see Col. pl. 19). For females, no hair decoration takes place apart from the design of the cut, oil and ochre, and added trinkets – they do not plait the hair (as do nearby Arab women), although the weight of the oil and ochre gives the impression of many tiny plaits. Hair on the sides of the head is kept short, allowing longer hair to grow from the top (see Fig. 1a). Girls may wear beads, pins, feathers or other objects in their hair, but since everything soon becomes either red or yellow, these trinkets are difficult to see. Should a girl acquire a shiny brass hair clip, however, she may attempt to keep it free of oil and colouring. The length of a girl's hair varies according to taste (see Col. pls 6, 7, 15).

On taking a skirt at the consummation of marriage, a girl shaves her head and keeps it groomed. On becoming pregnant, shaving and grooming the hair ceases until after the baby is born, when the mother again shaves and begins to keep her hair groomed once more. Most female hair grooming follows the same cycle on subsequent pregnancies. Barren women rarely shave their heads, until menopause, when all women keep their heads shaved (see Pl. 3). When a woman's hair style is not dictated by pregnancy, however, she may wear it in various ways, including using the shaved *kadūndōr* strips of the young men (see Col. pl. 15).[34]

The essential cut of men's hair is age-grade specific, and has already been described. Except for the restriction on colours used, however, grooming is the same for both *lōeɟ* and *kadūndōɟ* hair styles. To the closely cropped hair (hair is never allowed to exceed about one-half to one-third of an inch in length) is added beeswax. This results in a type of cake, as the beeswax is not rubbed in but simply stuck on. The wax cake is stippled with a comb or small stick, and then dusted by shaking on the appropriate colour. This results in an extremely attractive matt finish which, as mentioned, is protected in order to last (see Col. pls 1, 4, 5, 11, 18, 20, 25).

Hair decorating is done, of course, before body designing (see Col. pls 18, 20) – otherwise the dusting on of colour might ruin a body design. Once the hair decoration is a few days old and is beginning to look worn (the stippling no longer evident, the wax cracking and coming off the hair), the wax will be picked off, rolled up, and stored for future use. As it is not rubbed into the hair, it is not difficult to remove. After many uses, the wax is thoroughly impregnated with colouring material and general dirt (the term for hair-grooming wax, is, in fact, *ɲerɾā* – a term best glossed as 'dirt').

Young men may attach feathers or bits of coloured ribbon to the *ɟūm* at the crown of the head, or a row of chicken, ostrich, or forest bird feathers (see Col. pls 1, 2, 4, 20, 21, 25, 26) along the sagittal crest – perhaps reversing the direction of the feathers on either side of the *ɟūm*. Sometimes a series of thorns or seed pods will be used (see Col. pls 18, 27). Certain of these thorns are ritual as well as decorative, particularly for new bracelet fighters (*kadūndōɟ ēya*), and are regarded as necessary to ward off evil eye (*cē cūcō*), keep an opponent's blow from penetrating the head, or to ensure that the head blows glance off without damage. The entire hair fashion may also be sprinkled with herbs (*taō*) for protection – or with bits of blueing or ground mica for decorative flair.

THE BODY

Before we study designs, we must look at the Southeastern Nuba physical conception of the anatomy and its relationship to design. There are terms for practically all muscles visible on the body surface, and also terms for the depressions between muscles. Splitting the body in half below the neck, there are fifty-three terms in common use (excluding nine of the spine) which may be easily recalled by any youth who has begun wrestling and decorating. And there are many other terms which refer to posture, stance, aspects of the body in motion, perspective (see Table 5), and many types of walks, gaits, steps, prances and skips. Squatting, for example, involves not one lexeme, but three, for squatting with the feet flat, yet the body pitched forward (*lemɟ*); for squatting with the feet flat and the body resting low to the ground, the legs fully bent

(*tŭrmā*); and for squatting, the body resting on the ball of the foot, and heels suspended, thighs against calves (*fōrga*).

TABLE 5: *Sample of general body shape vocabulary*

Designata (concord prefix for singular third person, where required)	Denotata (descriptive gloss)
kōlōtōʔēt	tall (length, not relative)
ketlēŋ	short (antonymic contrast to tall)
nkōwa	fat (general)
kēŋgeragaʔak	thin (antonymic contrast to fat)
kertēʔēt	firm
tera	dumpy (antonymic contrast to firm)
djibū	square shouldered (*en face*)
kerē	sloping shouldered (*en face*)
bakabak	broad shouldered (*en face*)
kēkēa	broad shouldered (profile)
kwōŋera	stomach same size or larger than chest (*en face*)
kapōlēlē	stomach same size or larger than chest (profile)
kriŋin	stomach smaller than chest (*en face*)
kernū	stomach smaller than chest (profile)
nyŕōrō	bow-legged
tāwū	triangular torso (*en face*)
wawōʔūl	straight torso (*en face*)
ōtūmkabet	thick-necked (*en face*)
takera	rounded back (profile)
twēntōr	straight back (profile)

Body surface conditions also exhibit a large vocabulary. A swelling is lexically distinguished according to whether it is caused by a bump or blow, or by internal conditions. And there are four labels for scars – for those resulting from (1) decoration, (2) accidental puncture or cut, (3) lesion from internal cause, and (4) wound from bracelet fighting. Various rough patches, discolorations and skin rashes are each lexically labelled, and each has a specific set of herbal poultices to alleviate and treat the condition.

ARTISTS

Not all men are as enthusiastic or as talented in decorating as others. For those who attempt to design and are less-talented, there are the sanctions of ridicule – freely exercised by anyone older than the artist. Any individual of an age set senior to one's own can chastise, lecture, and pass judgment on one's own

activities and decorating efforts. Those whose techniques do not improve with practice usually confine themselves to simple *fōrē* designs (see Table 6 below), or cover the body totally with shiny black *gūmbā*. If a poorly executed design appears, particularly if it is a representational design, men elder to the artist will tell the artist to remove it – repeatedly asking him what he is trying to do, then expressing the correct way to execute the meaningful design (in feature code definitions or expression of transformational operations, see chapter eight below). If it is a sloppily executed non-representative design, similar queries about its meaning will be made to embarrass the artist, or comment will be passed on how the design highlights an unattractive feature of the artist's body – a *coup de grâce* to ensure the unsuccessful design's removal (artists are, of course, wearers, except in the case of designs on the back). The errors manifest are twofold: inadequate technique in execution of a design that is congruent with accepted treatment of the body; and designs, however excellent in technique, which are 'ungrammatical' *vis-à-vis* the body – which are inappropriate to body designing for culturo-aesthetic reasons (see below, p. 84).

But it is not often that poor designs are produced. Older boys and young men know the expectations in personal art and will attempt to maintain these, or occupy themselves, as mentioned, with less elaborate (but fully appropriate) designs.

Lōęr boys often experiment with colours, particularly off-yellows and oranges (see Col. pls 10, 19), and occasionally this is judged to be a violation of age-grade colour rules by *kadūndōr* and *kadōnga*. If a youth attempts to use a colour to which he is not yet entitled by age-grade membership, he may be whipped or beaten by his immediate elders.

Boys also experiment with designing, but several standardised techniques have become apparent, and complex designs normally proceed from basic elements to greater detail. For example, in depicting the total shape morphology of several series of birds, artists begin with two rows of parallel dots, in three pairs, two dots to each row (see Fig. 5a). Or in the whole-shape morphological representations of several species of large cats, artists start with two parallel lines (see Fig. 5b).

Lines themselves are usually the width of the object with which they are executed (i.e., a finger tip or a bit of straw). The straws used to apply design are seldom as much as one-quarter of an inch in width – but a single line can expand, to become part of another design, or to become a central feature of the design itself (see Pls 11, 16, 27, 38, 43, 44). They can expand to become triangles, or until they have sufficient width to split into two lines of equal size. Lines may also fade – into another design or to a point, or to an imaginary point out of the viewer's sight. Artists commonly carry lines into their hair fashion or under

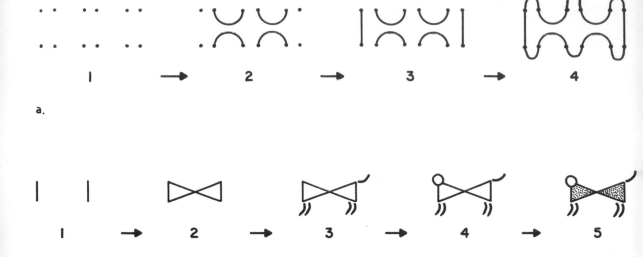

a.

b.

their arm – giving the viewer the impression that they stop out of sight, or meet at a common point, such as the *r̥um* tuft at the back of the head (see Col. pls 16, 26; Pls 10, 11, 16, 22, 26, 39, 43, 44). Lines need not be continuous, though they usually are. Non-continuous lines may give an impression of representation, when they are not (see Pl. 24 – where the abrupt ending of the two lines under the left side of the mouth give the impression of animal or bird legs). Artists curve lines, either slightly (an illusion sometimes created by expansion or fading, particularly on the curved surface of the face or body – see Col. pls 26, 27; Pls 16, 19, 35, 43) or in more pronounced fashion, to form swirls or convoluted designs (see Pls 36, 45). Tight curved lines are much more difficult to execute, for there are limitations on material (thickness of applicator) and on technique (for on the face, all designing is done with one hand and in mirror image – see Col. pl. 20).

The space between primary lines may be treated as a secondary surface to be designed more thoroughly – with cross-hatching or some other designed fill. Should this occur with representational designs, an altered representation sometimes results. This artistic use of space, however, is never allowed to interfere or obliterate the critical elements necessary for members of the culture to distinguish and identify the representations, should preservation of meaning be desired. But as has been repeatedly emphasised this is a secondary consideration.

Sometimes a line in colour shadows a primary black design or black design line (see Col. pls 11, 25, 27; Pls 39, 40, 44). If so the coloured line is usually

Figure 5
Drawing Techniques
(a – generalised bird; b – generalised leopard)

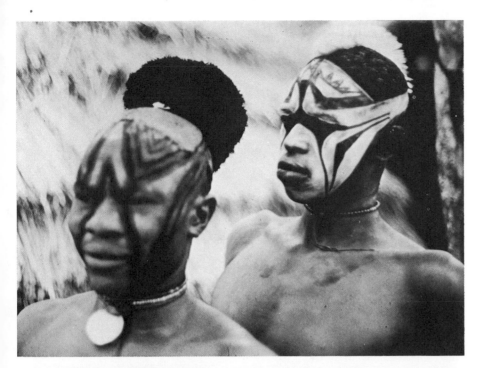

Plate 43
Non-representational
nyūlaŋ design form type
facial designs

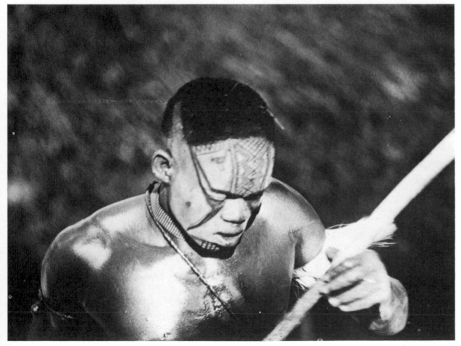

Plate 44
Nyūlaŋ design form type,
with *Type 1* whole shape
morphology additions

69

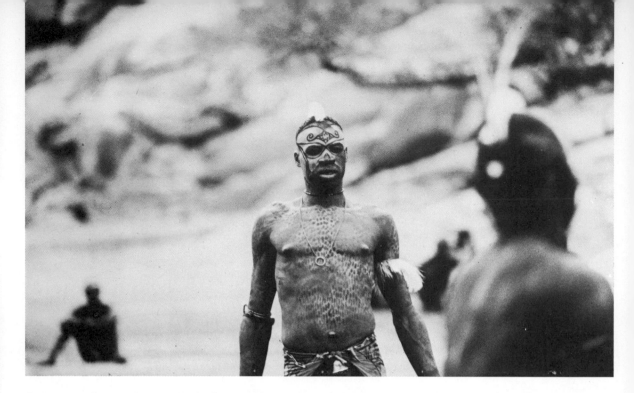

Plate 45
Symmetrical curvilinear
facial design with *tūrkā
tera* representational body
design

the exterior line and is applied after the basic colour (normally black) design. Similarly colour can be used as fill to a design whose outlines are black (see Col. pl. 16; Pl. 26). And occasionally the point of meeting of two colours which are not sufficiently contrasting (such as red or yellow) may be made more evident with a black line at the point of contrast.

Except at the height of the agricultural season when time is insufficient (and for periods at the far farms – see above, p. 56), young men of the final *lōeṛ* sets and junior *kadūndōr* sets attempt to keep on oil, if not body decoration. There is no season for particular designs, and it is impossible to predict what an artist will look like each day. It may be that the inspiration of a recent leopard kill will stimulate several leopard designs, but there is no necessary correlation. An artist normally avoids repeating a design on successive days, although his repertory will be limited by his abilities and the colours available. As age mates (*lamē kaŋgern*) of the same village section will normally decorate together (at any time during the day, though commonly in the later morning) – artists may be able to borrow ochre and other materials from one another. In visiting another village, an artist will be given oil and colouring material by his host.

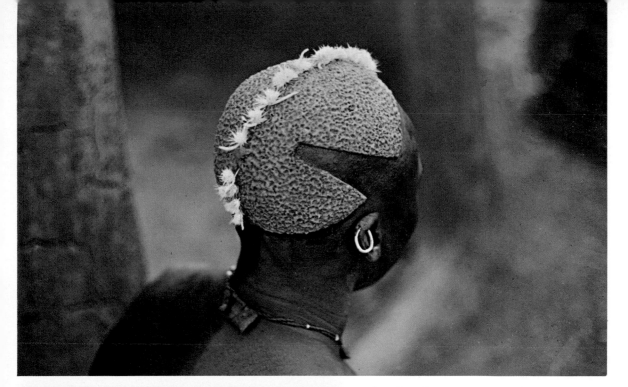

Colour plate 18
Kadūndōr hair style, newly waxed and dusted,
with ritually protective burrs along sagittal crest

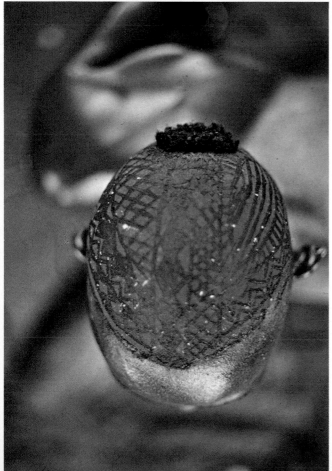

Colour plate 19
Lōeɽ hair style painted on shaved head (except for
ɽūm)

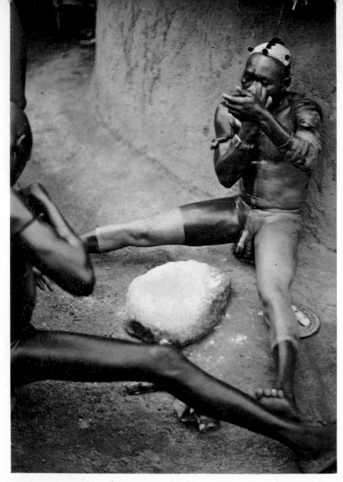

Colour plate 20
Kadūndōr decorating – slapping yellow ochre on right side of body, and decorating face with hand mirror

Colour plate 21
Group of young patriclansmen watching a tribal sport. Note the varieties of body and hair decorations

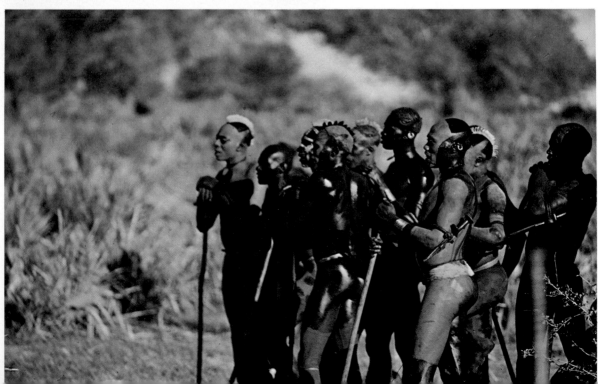

Design and Form

Designs and the body

[It is the task of painting] not to render the visible, but to make visible.
The object expands beyond its appearance because of our knowledge
of what lies behind it. Paul Klee

The natural symmetry of the body, both the vertical bilateral symmetry and the balance of the horizontal arrangement of parts, are relevant variables in the style, form and aesthetics of Southeastern Nuba personal art. The basic indigenous design form types are all types which are focused about aspects of this natural symmetry and balance. The five basic design form types for all designs (representational and non-representational) are listed in Table 6 (and illustrated in Fig. 6).

All Southeastern Nuba designs can be classified in one of the basic form types – types which relate the design to the symmetry and structure of the human body – whether or not the design is intended to be representational (see below, chapter eight).

Artists are fully aware of the relationships and similarities between the anatomies of animal species and man. In those designs where the surface characteristics of the animal are relevant and the human body serves anatomically as the animal, the animal morphology may be followed by corresponding feature placement on the artist's body. Of course human anatomy is unlike that of most animals, but this inadequacy is overcome by approximation, or by re-arrangement of the animal surface-anatomy relationships to fit the human body. The animal shape is simply made appropriate to the human form. Obviously the human physique is inadequate for any sort of one-to-one correspondence with a giraffe or a wasp. Simply scaling up or down the species to accommodate it to

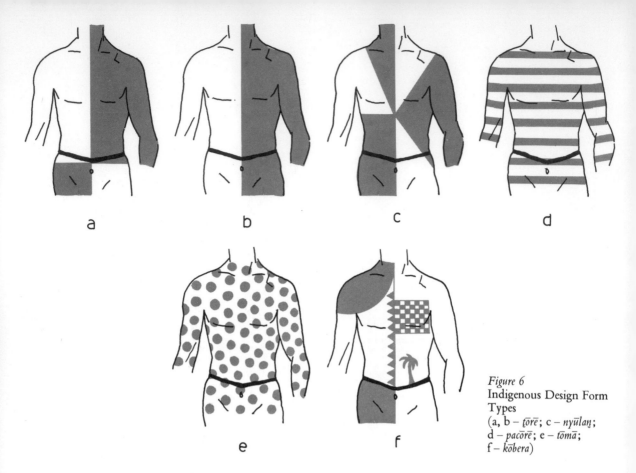

a b c d

e f

Figure 6
Indigenous Design Form
Types
(a, b – *ţōrē*; c – *nyūlaŋ*;
d – *pacōrē*; e – *tōmā*;
f – *kōbera*)

TABLE 6: *Indigenous design form types*

a. *ţōrē*	Designs orientated about a vertical division along axis of bilateral symmetry. See Fig. 6a, b; Col. pls 2, 12 (centre), 18, 20, 22 (right), 24, 28; Pls 7, 8, 17, 19 (left), 24, 25 (all), 34 (right), 35, 37 (centre), 42, 46, 47.	
b. *nyūlaŋ*	Designs which radiate from a single point along the axis of bilateral symmetry. See Fig. 6c and Pls 23, 41.	
c. *pacōrē*	Designs which divide body (or face) into many parallel sections, vertically, horizontally, or diagonally. See Fig. 6d; Col. pl. 27; Pls 6, 9 (second row, right), 32, 33, 37, 49, 50 (centre).	
d. *tōmā**	Uniformly distributed stamped or spotted designs. See Fig. 6e; Col. pls, 1, 2, 3, 5, 9, 10, 11, 12 (right); Pls 13, 21, 26 (left), 37 (centre, seated and far right), 42, 45, 48.	
e. *kōbera**	Non-uniform distribution of different individual designs, particularly panels of design. See Fig. 6f; Col. pl. 25; Pls 20, 51.	

* meaningful terms – *tōmā* is a species of rock hawk, with a spotted breast
 kōbera is a generic term for butterflies and some moths

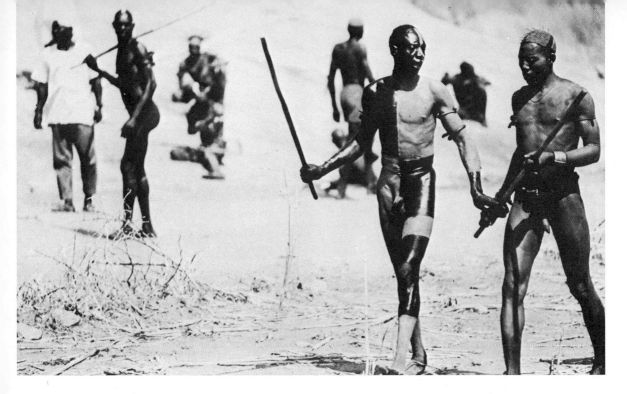

the body does not solve the anatomical correspondence problems. In these cases the animal representations are 'humanised' – that is, its morphology is adjusted to correspond to what it might be were it a man, and there is '. . . compensation for the renunciation of sensible dimensions by the acquisition of intelligible dimensions (Lévi-Strauss, 1966:24).' The body can thus be a whole giraffe (see Col. pls 1, 12 [right]; Pl. 48), an entire wasp (see Pls 6 [leg], 37 [striped figures right and left], 50 [centre]), or even both (see Col. pl. 2) without dissonance; relative size is not only projected, but is adjusted on to the human plane.

Where possible, of course, anatomical congruence is followed, and codable characteristics of natural species are represented on the anatomically appropriate part of the human body. An antelope (*ŋaír*) coded by stripes over its eyes will be represented by stripes above the artist's eyes (see Fig. 12j). A jackal with stripes on its legs will be represented with stripes on the legs (or arms) of the artist (see Fig. 7d). The same anatomical congruence can be seen in Fig. 7c – an ostrich (*kūŋgerū*) with bands on the legs – and in Fig. 7b, *wōta* – a forest cat species with contrasting belly and sides. Fig. 7a is also an acceptable *wōta* variation (note here the asymmetry, but careful maintenance of balance).

Occasionally some incongruities result, but they never obliterate the critical attributes which it is necessary to identify. For example, a type of hyena (*kamūr-waŋ*) is represented by heel-of-hand sized yellow spots on black background (see Pl. 52). On the hyena these spots are found on the back only. Since an

Plate 46
Balanced *tōrē* design form type. The designed man is restraining his younger patrikinsman at tribal sport

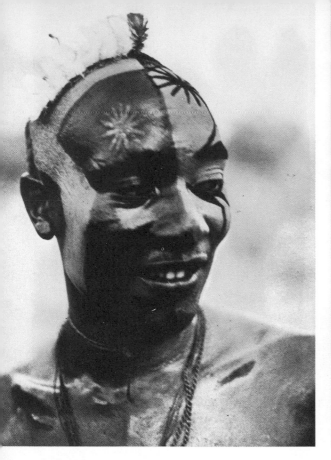

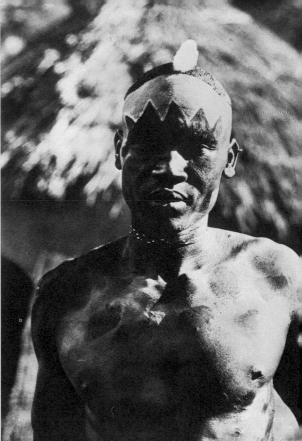

artist cannot decorate his own back, a *kamūrwaŋ* representation can be identified by this particular colour contrast in this particular size dimension, no matter where on the body it may be found – the latter variable being a function of artistic convenience as much as anything. And several rodent species with stripes on the back (see Table 8) are coded on the human surface with stripes on the artist's torso, *en face* – as designing the back requires the aid of another person and such aid normally results in a totally different design (usually of *Type 1*) on one's back.

Even with the aforementioned incongruence, however, one will never see a body design of an animal whose codable surface characteristics are on its head on any other part of the body except the face. Of course for some potentially codable animal characteristics, particularly shape attributes, such as the horns of antelope, the trunk of an elephant, or a giraffe's neck, there is no possible anatomical correspondence. Since in these cases the characteristics are relatively rare, the animal is normally represented in whole morphological outline, with prominent attention to shape details – a simple depiction of shape morphology. Here the body is ostensibly just a surface on which the codable characteristics are

Plate 47
Balanced *tōrē* facial design with sophisticated attention to colour weight

Plate 48
Dūn body design (compare with Col. pl. 1)

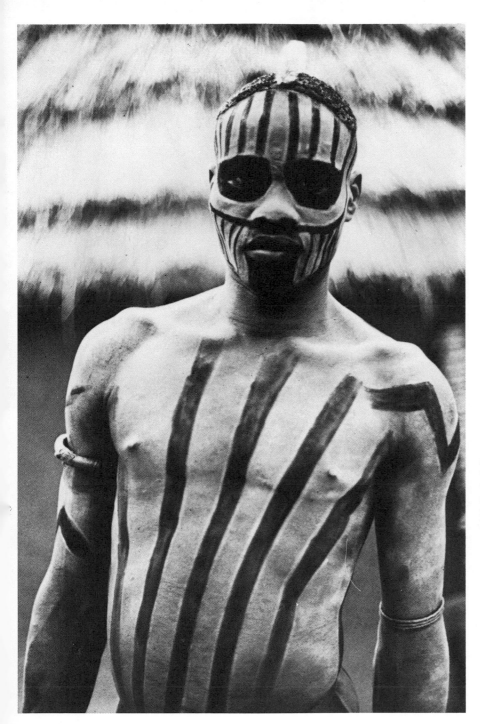

Plate 49
Non-representational
pacōrē design. The yellow
outline round the black
eye design marks it as
non-representational (i.e.,
not *daṇ daka awlad ḥēmed* –
No. 21, Table 8)

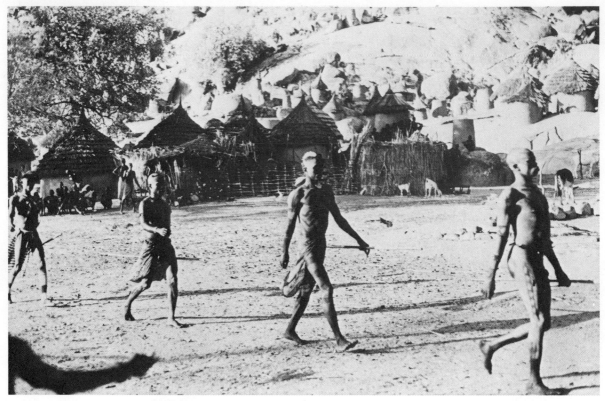

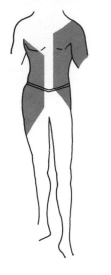
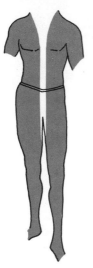
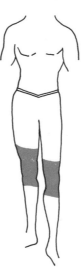
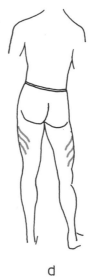

a b c d

Plate 50
Kadūndōr of same village section going to *nyertuṇ* dance. The first figure has *ŋōrā* design on leg; the second figure exhibits a *Type 3b wōrtḥa* species whole body design

Figure 7
Representational Body Designs, Type 3a
(a, b – *wōta*;
c – *kūŋgūrū ka lelṛ*;
d – *taliṇl*; see Table 8)

78

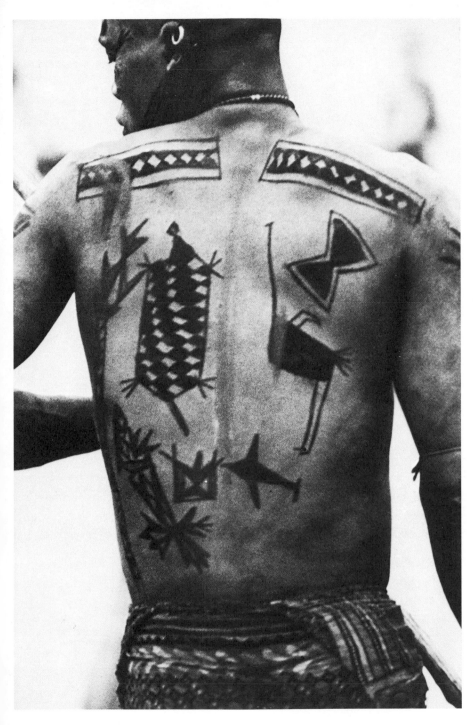

Plate 51
Kōbera design form type –
executed on back by an
inexperienced artist
committing no semantic
violations, but failing
aesthetically

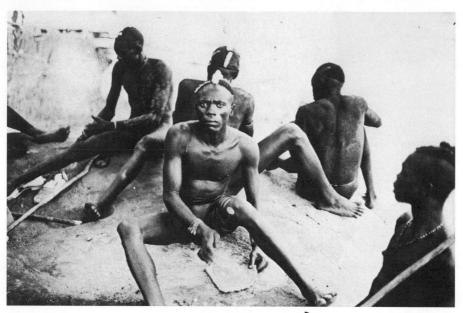

reproduced in a culturally-acceptable iconic manner (see Pl. 20; Fig. 8a, b, c; Fig. 9). This is commonly a whole animal representation, but if most of the animal's body is irrelevant to identification, it will emerge in very stylised form, while the morphological characteristics critical to identification are produced in accurate detail. In such cases the portion of the animals unnecessary to identification are often indistinguishable from other species (see bodies of antelope, Fig. 8a, b, c).

Even here, however, the plastic surface of the body may be used in aesthetic ways, and the critical characteristics may be placed so as to emphasise one portion – the contour of the jaw bone and the curve of the forehead (both horizontally and vertically) are, for example, frequently considered (see Col. pls 24, 25): a shoulder or biceps may become the bulge of a tortoise shell (see Fig. 10); the bulge of a back muscle may become the rump of a giraffe; and the contours of the chest may become a third dimension in illustrating the horns of antelope (see Fig. 9) – even though contour is not a semantic variable. The eyes are particularly important in this regard – they may become the centre of an elaborate bird's wing (see Pl. 47, right), or a lightning strike (see Fig. 11, and Pl. 6, right).

If a design is executed on but one portion of the body, the rest of the body surface may be used for semantically unrelated designs. Two species can thus be represented on the body at the same time (see Col. pls 2, 12 right; Pl. 13), or the body can manifest both representational and non-representational designs

at once (see Col. pl. 27; Pls 38, 42 [left not representational]). The face frequently is a separate design (representational or non-representational) from the body (see Col. pls 1, 2, 3, 9, 10, 11, 12, 27; Pls 6, 13, 21, 26, 37, 38, 42, 45, 48), and in the *kōbera* design form types (see Table 6 above), considerable variation is possible. In Col. pl. 2 and Pl. 37 (centre), either half of the *ṭōrē* division of the body represents different species. In Pl. 51, for example, there are cowrie strips (*ŋōrā*) on the back of the shoulders, an anteater species (*karaca*) below the left cowrie strip, small meaningless designs below the right cowrie strip – an ostrich below this, and an aeroplane below the ostrich. Below the anteater (shown both in whole-shape morphology and in surface characteristic, but identifiable only from the latter) is another meaningless design.[35] This back illustrates the range of acceptable 'species' – mixed with non-representational designs. It is of interest also that the representational designs include those whose identification depends on their coded shape morphology and designs whose identification depends on coded surface characteristics – a distinction whose analytical relevance will be discussed below.

With exclusively non-representational designs, particularly on the face, there is frequently more freedom to emphasise, rearrange, or otherwise treat various features of the body. The more common situation is to elaborate or emphasise the body's symmetry, but designs may also rearrange this symmetry in some way – successfully, if balance is maintained (see Pls 8 [right], 12, 14, 19 [left], 27, 35, 42). Designs, however, which obliterate symmetry without planned rearrangement or careful attention to balance are completely absent. A certain amount of skewing may occur if the artist is attempting to balance another design on his body or attempting to obliterate an unattractive feature (see Pls 8, 12, 27, 42). For example, an artist may choose (create) designs which reduce the size of the nose or a forehead considered too large, enlarge eyes considered too small (see Pl. 49), or alter the shape of the head in some more culturally attractive way. The balance which must be maintained in these cases frequently gives the illusion of complete symmetry (see Pls 12, 27, and see below, p. 84).

Southeastern Nuba personal design is really a plastic art, as the body is a contoured and plastic surface. The rearrangements of animal species to accommodate the body may alter the iconic presentation of the species slightly – but the animal is not taken apart and redistributed to the extent, say, as American Northwest Coast art (cf. Boas, 1955) – an art tradition largely executed on non-plastic surfaces on which such transformations can be more successfully accomplished.[36]

Designs may frequently be focused on a single feature of the body's bilateral distribution of parts – on a single eye (see Col. pls 24, 28; Pls 6, 24, 27), for example, or a single arm or leg (see Pl. 6). If body symmetry is rearranged

Figure 9
Wōriṇ Antelope Horn and Surface Representation.
See Fig. 8c and 12c

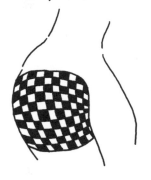

Figure 10
Tortoise Representation (*kerdaker*, Fig. 4r) and Body Contour

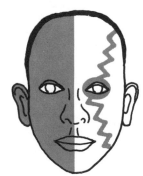

Figure 11
Modified *Ṭōrē* Design, with Lightning Motif

81

horizontally – i.e., for example, by orienting the viewer's attention to dual elements in the lower part of the face and a single element in the upper part of the face (altering, as it were, the eyes/mouth order in space) – the shift must be balanced. Only occasionally is a vertical skewing attempted, and it must be skilfully balanced to succeed (see Col. pls 9, 10, 25; Pls 19 [left], 35).

The *nyūlaṇ* design form type is in essence a horizontal skewing and a vertical skewing – a double splitting of the body. But if it is about a point on the centre of the bilateral vertical axis, the split is symmetrical and vertically balanced.[37] It is horizontally balanced if the point of skewing is at some culturally/acceptable horizontal division – the nasal dip, the centre of the chest, or the front of the belt (see Pls 17, 23, 25, 37, 38, 41). A *nyūlaṇ* form is considered successful only if the point from which radiations emanate is symmetrical bilaterally.

Analytically, then, there are two dynamic levels in the designing – the play on body symmetry and dimension on the one hand, and the rearrangement of designs and representations themselves to emphasise, obliterate, accommodate or balance a body feature on the other. These aesthetic operations, as will be seen below, take precedence over and cross/cut the formal levels – the operations on a set of semantic dimensions to generate the corpus of coded representations. They act as transformations – particularly inhibiting or steering coded representa/ tions in aesthetically appropriate directions. This is an orientation fully under/ standable as the successfully decorated body is more important than the trans/ mission of the semantic component of the design message.

The non-representational designs

The logic of images is the prime mover of constructive imagination.
<div style="text-align: right">Ribot</div>

By far the most common designs seen are non-representative. These may all be generally classified into one of the five design form types noted above (see Table 6 and Fig. 6), and will bear the name of the design type.[38] Their execution is aesthetic – for reasons of exposure and decor. Lévi-Strauss (1966: 29–30) has suggested that since non-representational art adopts 'styles' as 'subjects', it is in fact the same as representational art. Insofar as the non-representational art has aesthetic rules and stylistic principles which govern it, this must be considered; but the argument throughout this study has been the reverse – that representational art is in essence non-representative, for 'subjects' become 'styles', and their representation is not so important as the celebration and decoration of the medium, the body. Moreover, as will be seen below (chapter eight), much of the representational universe is highly formalised, and exhibits a grammar of its own. This is one measure which suggests that it is the proper exposure and appropriate decoration that is paramount in the art, not representation either of natural species or of 'styles'.

As surface coded representations will be treated below as a type of pictorial grammar, so styles can be considered an aesthetic grammar. It has been pointed out above that aesthetic rules are primary to all rules generating representations and could therefore be considered as general – even transformational – constraints or inhibitors which conform to cultural ideas of the attractive body.

Ideas about the body are primarily concerned with culturally-perceived

balance and symmetry – in other words, with what may be called form. In discussing concrete paintings, Worringer (Stabler, 1965:184) has expressed this:

> 'The aesthetic effect can only issue forth from that higher condition which we can form, and whose essence is to conform to certain rules, no matter whether this conformity is simple and easily discernible, or whether it is differentiated in such a way that it can only be sensed as the conformity of the organic.'

Culturo-aesthetic style (form) is paramount in both semantically meaningful and in non-representative designs, and it is commonly the case that a design will represent a natural species and yet this meaning be irrelevant to the desired effect on the viewer. For example, the common linear design on the side of the legs (like silk stripes on formal trousers, see Pl. 50 [right]) could be one of the several snake designs (see Fig. 4a–j), or a strip of cowries (see Fig. 4n, o) or a non-representative linear design such as in Fig. 13, and the same aesthetic effect is achieved. This is also true of the whole-body types of stripe or spot designs (*tōmā* and *pacōrē*, respectively – see Col. pl. 1, a species of giraffe, in contrast to Col. pl. 5, in which the body design is a meaningless carved-stamp design, but of much the same fundamental structure, size and colour contrast). It may be speculated, in fact, that this is why the fundamental semantic dimensions and attribute markers are so precisely defined and the representational designs produced so agreed upon – they are but variations in technique and execution to the same end as non-representative designs. The natural world simply furnishes an addition to the repertory of design forms – additions to the non-representational imagination of the artist within the paramount dictates of cultural style.[39]

Several features of style and form have been discussed in the previous section. It has been seen that critical form variables are balance and symmetry, in that order – that is, if symmetry along some natural axis (or cultural axis, such as the belt line) cannot be maintained or is deliberately skewed, then unless balance is maintained the graphic exercise is a failure and will be pronounced such by the ever-present critics of the endeavour. And I have indicated that designs which deliberately ignore or obliterate symmetry are attempted only by more sophisticated artists, for the maintenance of balance in these circumstances is more difficult (see Pls 19 [left], 35).

In Pl. 14 the artist can only be described as having played with his forehead. The asymmetrical and unparallel lines on the right side are balanced by a more rigid form – a geometric rectangle – on the left. Below the eyes a similar asymmetry is seen in the solid design – but here also balanced by the lateral extension under the right eye and a corresponding retreat of the mass under the left eye.

84

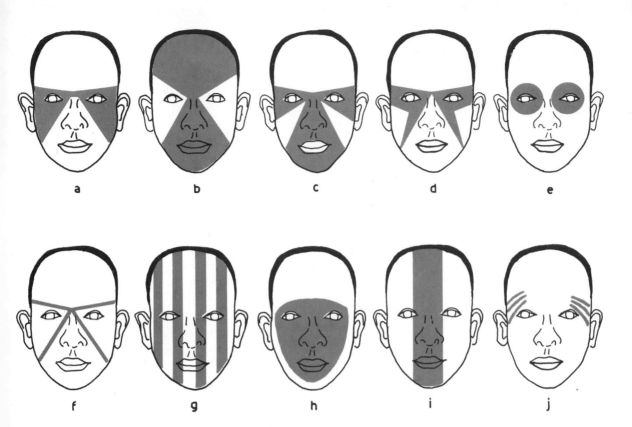

a b c d e

f g h i j

The faces of the artists in Pls 31 and 42 offer a similar example. The designs on the cheeks are quite different, yet with a careful maintenance of balance – a viewer does not have an impression of disharmony or imbalance. In Col. pl. 25, another meaningless line design is asymmetrical only in confined (and symmetric) sections – as under each eye, above each eye, and on the forehead. But the forehead design is delicately balanced, and the overall attention of the viewer is not drawn to one feature of the design, nor is there any violation to the natural distribution of facial features. In Pl. 27, where the natural symmetry is disturbed, it goes essentially unnoticed, so well balanced is the design – the rising solid black under the right eye compensating for the off-centre undesigned portion of the forehead. The fact that the row of white feathers (along the top of the head) is adjacent to the undesigned portion of the forehead, and the fact that both the undesigned strip and the white feathers are the same width contributes to the disguise of the asymmetry.

In the facial designs of Col. pl. 10 and Pl. 19 (left), there is a deliberate disregard of the bilateral symmetry of the face. In Col. pl. 10, this is slight, with the centre of this *nyūlaŋ* near a line of bilateral symmetry to the right of the nasal dip.

Figure 12
Representational Facial Designs, Type 3a (see Table 8)

85

The triangle on the left side, of which the left eye is the apex, is neatly balanced by the outlined linear form above the right eye. The artist illustrated in Pl. 19 (left) carries off the asymmetry well, for the darker portion of the design appears to be a sweep from a balanced *ḟorē* design on the right side of the chest, *around* the centre of the face, indicating its point of greatest sweep with a triangle oriented towards the left ear on a line from the left eye to the ear, and then back up to the centre of the top of the head. There is a hint of another design element in the same colour just above the right eye, an element introduced to assure the viewer that the space ignored by the active sweeping element is not forgotten, and to restore the viewer's appreciation of the balance which can be achieved in asymmetry.

Pls 10 and 11 illustrate slight, but deliberate 'secondary' alterations of highly symmetric facial designs. Pls 10 and 11 are left and right views, respectively, of the same design. This design, which requires the aesthetic factor of motion for its full consideration, is basically asymmetrical, but since this impression is perceived only upon motion, the design appears symmetrical and balanced to a viewer at any single perspective.[40]

The design of Pl. 35 is fundamentally a *ḟorē* design form type which involves a subtle play at the top of the forehead in what may essentially be described as *nyūlaṇ* design form directions. That is, the axis of bilateral symmetry becomes a point from which a *nyūlaṇ* design form type radiates.

On the face of the artist on the right in Pl. 8 is a black extension across the mouth and up over the right ear. This asymmetry is appropriate at this point, for the mouth already initiates a break or potential disturbance in the vertical bilateral design. It is probable, for example, that this design would have been considered aesthetically unacceptable had the black extension to the right stemmed from the forehead or the eyes.

Pls 2 and 18 illustrate slightly asymmetrical designs, balanced by factors external to the design. In Pl. 18 the artist has painted a slight crook in the lightning-like element coming off the hair line near the centre. This has been 'balanced' by the use of feathers on but one side of the head. Similarly, the artist in Pl. 2 has placed seeds in the hair on the right side of the head, to complement a slightly curved series of three parallel lines. This creates a balance to offset the bolder jagged series of two parallel lines on the left side.[41]

The most common facial designs are basically symmetrical, although there are commonly differential designs within broadly symmetrical divisions. Col. pl. 25 and Pls 12, 25, 31, 42 illustrate fine-line designs which are symmetrical about a vertical bilateral division, but with considerable variation on either side in secondary elaboration. In Col. pl. 25 and Pl. 31 (the same artist on different days – a young man particularly skilled in fine-line designing) there is in both cases a hint of orientation about the nasal dip for the asymmetric elements below

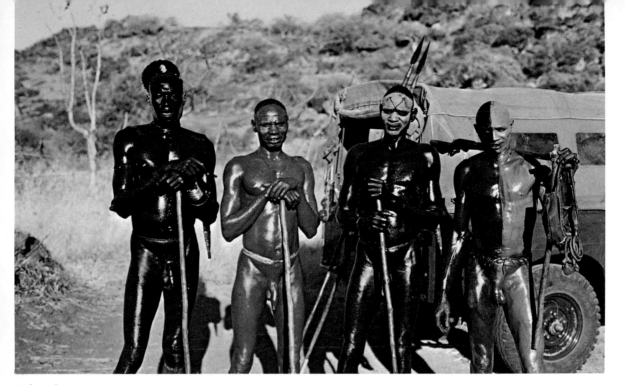

Colour plate 22
Freshly oiled *kadūndōr*. The colour of the person
second from the left is due to smearing of a
previous black and yellow *ṭōrē* design

Colour plate 23
Kadūndōr covered with *gūmbā* jogging to *timbrā*
fight

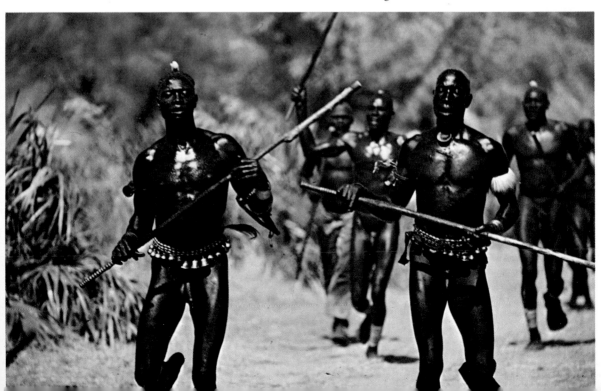

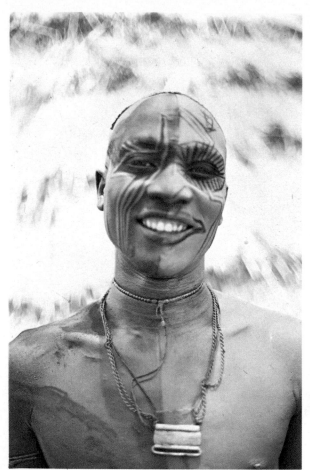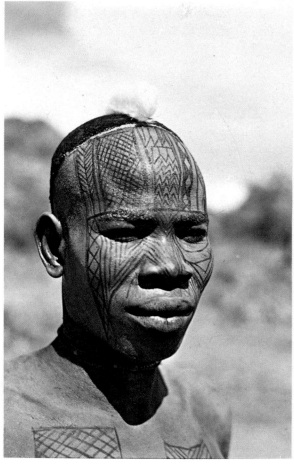

Colour plate 24
Ṭōrē design with facial elaborations. Note the
red ostrich on the left

Colour plate 25
Lōeɣ youth with fine-line facial designs

the eyes. In both cases the forehead designs are quite separate from the design below the eyes, and only on the outer extremities (essentially off the face) does the forehead design become part of the total facial design.

In Pl. 12 there is also the orientation about the nasal dip – this time from above the eyes. The design across the nose flattens it, and the eyes lie in the same series of horizontal planes initially established by these designs beneath them. The forehead design is here, as always, carried into the hair style, but in this case a particularly large contoured surface allows for a well-balanced series of elements, which only hint towards the nose (or nasal dip) in ways to direct attention, but not focus it. The focus is on the nose design – deliberate use of art to disguise, at least *en face* (and the perspective projected to the viewer), what is considered an unattractive facial feature, a rather pointed nose.[42]

The orientation of non-representational facial designs requires more comment. Many of these designs appear to radiate about the nasal dip (and are thus *nyūlaṇ* in form type – see Col. pls 1, 3, 5, 16, 26, 27; Pls 16, 25, 26, 38, 39, 40, 43). In Col. pl. 27 the artist has used different elements on either side of the forehead, but this in no way distracts from the nose-eyes-mouth orientation of the design. On the contrary, the artist's facial design in Pls 39 and 40 (same design, different views) is interesting in that the centre of design activity is uncertain. The nasal dip is one centre, as is a point on the nose indicated by the apex of the two heavy angles on either cheek each of which extend into the *kadūndōr* shaved strip. Then again the dark triangles beneath each eye are also centres of attention. This illustrates well another aspect of facial designing – the extent to which the hair fashion is relevant to the fundamental orientation of the design. A design element springs from a single strip of hair in Pls 19 (left) and 31, and here the shaved strips of the *kadūndōr* hair style are important. The shaved strips ostensibly meet at the *ṛūm* at the top and back of the head, and the bottom boundary of the shaved strips are from the *ṛūm* to a point just above the ear. This can be seen repeatedly in all Plates which illustrate this hair fashion. In Pl. 43, the artist on the right has added an elongated triangular element at the cheek which points up, in a real way, the orientation of the entire design to the nasal dip. The line stemming from the right eye, and the uppermost apex of the elongated triangle just mentioned, should come together at the *ṛūm* on the back of the head – using the shaved *kadūndōr* strips as a pathway. In many facial designs the impression is left that elements of the design might meet at the *ṛūm* if only the hair were not in the way. The *ṛūm* and the nasal dip, then, form the most important loci or orientation points for radiating facial designs. Another point at which designs appear to meet is under the chin at the neck (cf. Col. pls 1, 3, 16, 25, 27; Pls 8 [left], 19 [right], 21, 24, 25 [left], 36, 39, 40, 43), and this, combined with the eye-ear plane, offers a variety of options to the artist for basic orientations.

The artist's face in Col. pl. 28 exhibits a secondary design element oriented explicitly about the nasal dip and the top edge of the shaved *kadūndōr* strip. This design, however, is imposed on a basically-*ṭōrē* design form type – and is a subtle balance to offset the weight of the darker side of the face. The *ṭōrē* design form type is sufficiently imposing for secondary asymmetrical designs to be placed on its lighter half[43] (see Col. pls 24, 28; Pls 7, 8 [right], 17, 19 [left], 29, 35, 41, 47). Pl. 24 illustrates considerable designing on but one side of the face, although sometimes a basic *ṭōrē* design form type can exhibit designs on both light and dark halves (see Col. pl. 24, Pls 7, 35, 41, 47). Pl. 47 is an excellent example of balance – the use of several secondary designs on the lighter side of the face to off-set the weight of the darker side. Southeastern Nuba artists well understand the relationship of colour to balance and contrast. In Pl. 47, for example, the artist has to balance not only the yellow sunburst on the dark left side of the face, but also the dark side itself. This is accomplished by a slightly larger, and slightly higher black sunburst on the right (lighter) side of the face, plus the addition of a crane-type of figure on the light side of the face, the wing of which is the artist's eye, and the head of which the black sunburst. This delicate long-legged bird is a perfect complement to balance the heavy dark colour of the left side of the face. The use of the human eye as bird's wing has been mentioned previously.

In Col. pl. 24 the artist has diminished the weight of the dark left side by inserting a red ostrich. It is therefore unnecessary to provide so much 'ballast' on the lighter right side of the face to balance the colour on the left side.[44]

The colour-'weight' problem (brighter shades being 'lighter' in weight) is also considered in whole body designs (see Pls 7, 8, 17, 41). In Pl. 7, the four-finger-wide yellow stripe above the knee on the left, and the yellow stripe on the face, both balance (by lightening) the colour dominance of the left side. In Pl. 17, only one-fifth or so of the artist's body is dark – and is effectively countered by the greater amount of yellow, which covers at least two-thirds of the surface above the waist.

Another common method of colour balance in whole body *ṭōrē* design form types is to alternate the distribution of light and dark colours on either side of the body (see Pl. 46). The balance is achieved mechanically by the equal distribution of light and dark colours on both sides of the bilateral vertical axis. It is not uncommon to find *ṭōrē* design form types, however, in which one entire half of the body is a single colour, the other half in contrast (see Col. pls 12 [centre] and 22 [right]). Frequently these 'orthodox' *ṭōrē* types are found accompanied by a detailed and unrelated facial design, which serves to diminish attention (or at least moderate it) from the body division (see Pls 24, 25 [left]).

Where a *ṭōrē* design form type is balanced by an alternation of the colour distribution (see Pl. 46), it is of interest to note the points at which this takes

place (see Pls 7, 17, 19 [left], 23, 24, 25 [centre], 34, 41, 46), for the points of alternation express Southeastern Nuba aesthetic judgments about the horizontal divisions of the body. The most common points are the navel (Pl. 46), the throat (Pl. 24 – under the chin), mid-point of the upper leg (Pls 6, 7, 23, 34, 41, 46), mid-point on the calf (Pls 7, 34, 41, 46), mid-point on the lower arm (Pls 7, 8, 41, 42, 46) and mid-point on the upper arm (Pls 12, 25, 34). Some of these are also points about which *nyūlaṇ* diagonal radiation may be expected. At these points may be wide bands of colour contrast (see Pls 7, 46), or a complete contrast above and below the point. Less common points of contrast alternation are seen in Pls 19, 23 and 25 – at the middle of the chest; Pl. 17 – mid way between the navel and the chest. In these latter cases, however, the point is at a 'natural' dividing point – a muscular depression, or some very visible point at which the anatomy changes, where, in short, it is anatomically appropriate. Only occasionally is an artificial point used, such as the belt line (Fig. 6a, f and Pl. 41) and in these cases there is still 'anatomical' basis for the choice.

In non-*fore* design form types, the same situation is found – any part-design is placed on the body in a position which is oriented about these four or five basic horizontal points of division (see Col. pl. 21; Pls 5, 6, 16, 26 [right], 38). These anatomical points, then, may be regarded as aesthetic rules – stemming from perceptions of the attractive and balanced body – which channel designs and contrasts necessary to balance in and of themselves. As discussed above (p. 82), the interplay between balanced design and balanced body generates all aesthetic and stylistic rules – rules which are paramount (and primary to) rules of semantic meaning.

Complete symmetry in facial and body designs is very common. In facial designs the forehead may be treated independently from the rest of the face, except at left or right extremities – that is, designs can be absolutely *en face*, rather than depend on the aesthetic variable of body motion for their complete effect. Where the forehead is treated apart from the rest of the face, the point of departure is always from a horizontal line just above the eyes (see Col. pls 25, 27; Pls 8 [left], 12, 30, 31, 36, 42, 45).[45] Where the forehead is an integral part of the design of the total face, the eyes are often enclosed by other symmetrical elements (Col. pls 3, 5, 10, 11, 12 [left], 16, 22 [right centre], 26; Pls 6, 14, 15, 25 [left], 26, 27, 44, 49), and only rarely are they ignored or obliterated. As discussed above (p. 82), in the whole-face symmetrical designs, the nasal dip is a dominant point of focus – which pitches design components on either cheek under the eyes, and commonly into the hair at the *kadūndōr* strips (if the artist has the shaved strips). The jaw is usually treated as some approximation of the beard (see Col. pl. 27, Pls 15, 44, 49).[46] This may be a full beard orientation (Pls 15, 49) or simply a small design to balance components higher on the face (Col. pl. 27, Pl.

44). The jaw line may be followed *in toto*, in which case the design requires the aesthetic variable of motion for its appreciation (see Pls 15, 49), or it may stop, and the design is oriented *en face* only (Col. pl. 27).[47] In total facial designs, then, motion is always a relevant aesthetic variable.

The above section has concentrated on the several dimensions of aesthetic constraint and rules of style and form. There are the rules of acceptable colour contrast, and balance and symmetry – involving on the one hand the perception of natural body symmetry and ways of altering and enhancing it, and on the other hand the factors of balance in the designs themselves – in which colour weight is an important factor, particularly if symmetry is disturbed. The designs themselves have been shown to be oriented about a limited number of specific types (see Table 6), but in execution also to involve viewer perspective (and frequently thereby, the artist's body in motion), hair fashion, and judgments about appropriate anatomical points for their orientation.

Most of these rules and patterns will also be found to govern representational designing to be discussed below. The rules just considered are aesthetic. They are of form and style. But it has been repeatedly emphasised that these are paramount (and primary) to the communication of the representational meaning. Only in unsuccessful designs, however, will semantics and 'syntax' (aesthetic form) be found in conflict.

CHAPTER EIGHT

The representational designs

Nature is only a dictionary
Baudelaire

The various representational designs have been discussed in general outline above (see p. 75). Representational designs may be divided into: (1) those designs in which the shape morphology of the natural species is alone relevant to identification (in which case the body is but a surface on which to draw, and is normally anatomically irrelevant to design identification); (2) those designs in which surface characteristics as well as shape morphology are necessary for identification; and (3) those designs in which surface characteristics of natural species alone are coded. In this latter case, placement on the human body is frequently relevant to identification, and there must here be a further analytical division between those designs peculiar to a portion of the human anatomy (i.e. species whose coded surface characteristics are represented on an anatomically appropriate place on the human body), and those designs in which the coded surface characteristics are not limited to one portion of the human anatomy. Even in this latter it cannot be assumed that body anatomy is irrelevant – but simply that the design is regarded as potentially covering the human body, and as long as a sufficient portion is designed to permit identification the species is acceptably represented. This design type scheme can be represented in Table 7.

For designs of *Type 1*, it should be clear that each production can be new and unique, and that the universe is relatively unlimited. With the introduction of new shapes with meaning (such as word strings – LONDON, HUNTS – or the Kologi mosque, or aeroplanes), the design universe expands and is theoretically infinite.[48]

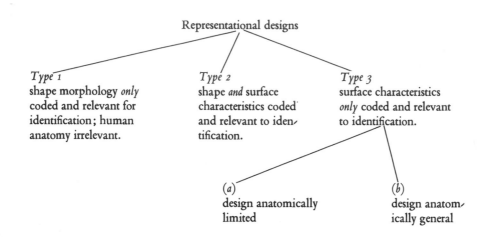

It is also important to note that even though many of these are unique shapes and that the universe is unlimited, they are usually shapes which can be easily recognised and labelled (named) by others. Except for the English word forms (which are 'identifiable' by any reader of English), most shapes had been seen by most people. No one, in other words, failed to identify an aeroplane (illustration in proper perspective) represented on the body. For these representational *Type 1* designs coded by shape morphology only, there is little stylisation – identification depends on rather accurate duplication, and formalisation is minimal. They are, in general, graphically complex iconic productions.[49]

Type 2 and *Type 3* designs, however, are precisely limited in number, for the representation of surface characteristics is limited by but two dimensions, and agreed-upon combinations of lines, dots, colour contrasts limit the parameters for their production. The addition of shape attributes (*Type 2*) plus surface characteristics does not provide many additions to the universe. The shape components discussed for *Type 2* are primarily framing or border attributes rather than unique shape features, and thus the universe is not enlarged significantly when they are added to specified surface designs. For designs of *Type 3*, there are those confined to a specific area of the human body (*Type 3a*) and those which are general to the body and usually cover most of it (*Type 3b*). Although there is theoretically a wider latitude for production of *Type 3a*, the natural universe is limited, and not many species are reproduced whose identity codes involve restricted distribution of surface characteristics. All these repre-

sentations are part of a formal and finite iconic system, and the purpose of this section is to write rules for the description and generation of this corpus.

ELICITATION OF FEATURE CODE GLOSSES

For many designs of *Type 2* and *3*, a culturally accepted and agreed-upon set of feature components has evolved by which it is possible for members of the culture to identify and produce the representational designs. The eliciting and discovery of these feature codes proceeds like the discovery of the structure in a lexically-coded folk classification, and the most formidable task is asking the right kinds of questions and seeing enough representations about which to ask these questions. It is normally of no benefit to ask what a given leopard species looks like – one must see a representation and be told it is a particular leopard species. Ideally one would like to be able to ask what is minimally necessary to represent a particular species of leopard, and how this leopard species minimally differs from another species. But this was not possible, and only after seeing one species in contrast with others and eliciting the meanings of similar designs could I begin to see how and along what dimensions the species differed. It eventually became possible to uncover all the semantic dimensions necessary to effect a shift in meaning in the graphic universe, and assign feature-attribute values. Testing proceeded by queries about slightly deviant productions, and by generating actual designs with operations of the feature attribute values on the semantic dimensions, and then asking questions about the meanings of these productions.

Often I would generate or see meaningless designs and be told they were so, but on production (or natural occurrence) of a design which did in fact represent a natural species, I could see what features were necessary to define the species graphically and could sometimes express this in an identity or feature code – a descriptive label, such as 'more than four three-finger width solid black stripes on yellow background', or, 'more than four fingertip-sized solid black spots, ungrouped, on white background'. Artists do not often verbally articulate these codes, but can usually agree to their adequacy (or inadequacy) once presented with them. The identity codes (descriptive design glosses) or the feature representations can be seen in Table 8.[50]

It is important to note the allomorphs for many of the representations[51] (Fig. 4g, h; i, j; n, o; p, q; Fig. 12a, b, f; Fig. 7a, b). Some of these patterned variations were seen by me, others were elicited – and I took care to question where potential variation or ambiguity might exist. Allomorphic variation is particularly relevant to designs of *Type 2* and *Type 3a*, although designs of *Type 3b* may have allomorphs if other colour contrasts are acceptable.

93

Designata	English approximation	feature code (or design)	illustration
1. *dēn̄ā pōrpōrla*	poisonous snake *sp.*	see design	Fig. 4a
2. *dēn̄ā kapergēt*	poisonous snake *sp.*	see design	Fig. 4b
3. *dēn̄ā nyōr*	poisonous snake *sp.*	see design	Fig. 4c
4. *dēn̄ā ten*	poisonous snake *sp.*	see design	Fig. 4d
5. *dēn̄ā amgōsēa*	poisonous snake *sp.*	see design	Fig. 4e; Pl. 38
6. *dēn̄ā kaparatōtō*	poisonous snake *sp.*	see design	Fig. 4f
7. *dēn̄ā kwa*	poisonous snake *sp.*	see design	Fig. 4g, h; Col. pl. 25
8. *wōm*	python *sp.*	see design	Fig 4i, j
9. *cada*	mountains	see design	Fig. 4k
10. *cūthō*	female breasts	see design	Fig. 4l
11. *gaṇ*	Shilluk necklace	see design	Fig. 4m
12. *n̥ōrā*	cowrie shells on leather strips	see design	Fig. 4n, o; Col. pls 19, 25; Pls 38, 50 (first figure)
13. *karaca*	anteater *sp.* (pangolin)	see design	Fig. 4p, q
14. *kerdaker*	small tortoise *sp.*	see design	Fig. 4r
15. *kēō*	rain	see design	Fig. 4s
16. *krā*	chipmunk-like forest rodent *sp.*	>four 1 finger width B/y stripes, vertical (on back)	—
17. *nyerwōn*	chipmunk-like village rodent *sp.*	>four 1 finger width B/w stripes, vertical (on back)	—
18. *wūtrū*	large stiff-haired mouse *sp.*	>four 1 finger width Y/b stripes, vertical (on back)	—
19. *dōn̥eraṇ*	forest bird *sp.*	four 1 finger width B/w stripes, vertical (on face)	Fig. 12g
20. *jaēn̥ jaēn̥*	vulture *sp.*	one 3 finger width A/a stripe, vertical (on face)	Fig. 12i; Col. pl. 12 (right)
21. *daṇ daka awlad hēmed*	cow (Baggara tribal section type)	one (or two) 3 finger width B/w (or W/b, B/y, Y/b) spot (spots) on eye (eyes)	Fig. 12e
22. *kūdūker*	dove *sp.*	two 3 finger width R/a spots (on eyes)	—
23. *wōtē wūn̥in*	black forest monkey *sp.*	one full-hand width Y/b (or W/b) spot (centre of face)	Col. pl. 4; Fig. 12h
24. *wōtē wōr̥ē*	red forest monkey *sp.*	one full-hand width R/a spot (centre of face)	Fig. 12h
25. *n̥air*	small forest antelope *sp.*	three less-than-1-finger width B/a curved stripes (over each eye, oriented towards ear)	Fig. 12j

Type 2 (rows 1–15)

Type 3a (rows 16–25)

26.	*talịṇl*	mountain jackal *sp.*	three 1 finger width B/a curved stripes (on outside of each thigh)	Fig. 7d
27.	*kūṇgūrū ka lelr*	ostrich *sp.*	thigh-to-calf Y/b stripe (both legs)	Fig. 7c; Pls 16, 26
28.	*wōta*	forest cat *sp.*	see design	Fig. 7a, b
29.	*wōriṇ*	forest antelope *sp.*	see design	Fig. 12c
30.	*cipaliṇ*	masked bird *sp.*	see design	Fig. 12a, b, f
31.	*kārū*	small savanna deer *sp.*	see design	Fig. 12d

32.	*tūrkā tera*	leopard *sp.*	>four 1 fingertip B/w spots, close, ungrouped	Col. pls 3, 11; Pls 26, 37 (centre, far right), 45
33.	*kōk ? wara*	short-tailed forest cat *sp.*	>four 1 fingertip B/w spots, apart, ungrouped	—
34.	*kel*	cheetah *sp.*	>four 1 fingertip B/w spots, grouped	—
35.	*dūn*	giraffe *sp.*	>four 3 finger (heel of hand) B/w spots	Col. pl. 1; Pl. 48
36.	*tōmā*	rock hawk *sp.*	>four 1 fingertip B/w hollow spots, close, ungrouped	Pl. 42 (right half of body)
37.	*daṇ ka fellata*	cow (Fulani type)	>four 1 fingertip B/w hollow spots, grouped in fours	Pl. 13
38.	*tūrkā tōrē*	leopard *sp.*	>four 1 fingertip B/y spots, close, ungrouped	Col. pl. 9
39.	*tūrkā tētē*	leopard *sp.*	>four 1 fingertip B/y spots, apart, ungrouped	—
40.	*tūrkā cēpōra*	leopard *sp.*	>four 1 fingertip B/y spots, grouped	—
41.	*krendelnya*	giraffe *sp.*	>four 3 finger (heel of hand) B/y spots	Col. pl. 2 (right half of body); Col. pl. 12 (right)
42.	*ṇerdūdū*	large forest bird *sp.*	>four 1 fingertip Y/b spots, close, ungrouped	Pl. 52 (left background)
43.	*ōra*	small mountain cat *sp.*	>four 1 fingertip Y/b spots, grouped	—
44.	*kamerwaṇ*	hyena *sp.*	>four 3 finger (heel of hand) Y/b spots	Pl. 52 (centre foreground)
45.	*tegen taka awlad hēmed*	calf (Baggara tribal section type)	>four 1 fingertip W/b spots, close, ungrouped	—
46.	*wōṛl*	large lizard *sp.*	>four 1 fingertip W/b spots, apart, ungrouped	—
47.	*ṇōrōrō*	mountain burrowing owl *sp.*	>four fingertip W/b spots, grouped in fours	—

Designata	English approximation	feature code (or design)	illustration
48. *tōmer*	poisonous insect *sp*.	>four 3 finger (heel of hand) — W/b spots	
49. *kōkarō*	short-tailed cat *sp*. (leopard?)	>four 1 fingertip R/a spots, close ungrouped	Col. pl. 10
50. *umuth*	large forest cat *sp*.	>four 1 finger width W/b stripes, not vertical	—
51. *ṇer*	zebra *sp*.	>four 2 finger width W/b stripes, not vertical	Pl. 9 (decorated male on right)
52. *werō*	small forest deer *sp*.	>four 1 finger joint W/b dashes, apart	—
53. *ānē*	savanna antelope *sp*.	>four 3 finger width W/b stripes, not vertical	—
54. *ṇbōr*	striped field mouse *sp*.	>four 1 finger width Y/b stripes, not vertical	—
55. *tagōkē*	large fox *sp*.	>four 2 finger width Y/b stripes, not vertical	—
56. *kera*	large forest owl *sp*.	>four 1 finger joint Y/b dashes, apart	—
57. *lulpin*	edible caterpillar *sp*.	>four 3 finger width Y/b stripes, not vertical	—
58. *lā*	honey-bee *sp*.	>four 1 finger width B/y stripes, not vertical	—
59. *wōrlth*	ring-tailed cat *sp*.	>four 2 finger width B/y stripes, not vertical	—
60. *kamūlaṇ*	hyena *sp*.	>four 1 finger joint B/y dashes, apart	Pl. 21
61. *wōrtha*	rainy season caterpillar *sp*.	>four 3 finger width B/y stripes, not vertical	Pl. 50 (centre figure)
62. *wēā kōra*	wasp *sp*. (small)	>four 1 finger width B/w stripes, not vertical	Col. Pl. 2 (left half of body); Pls 6, 37 (striped figures on left and right)
63. *wēā patʔṭra*	wasp *sp*. (large)	>four 2 finger width B/w stripes, not vertical	Pl. 37 (left half of seated centre figure)
64. *kōkōrl*	short-tailed mountain cat *sp*.	>four 1 finger joint B/w dashes, apart	—
65. *wathen*	forest antelope *sp*.	>four 3 finger width B/w stripes, not vertical	—

Type 3b

In Fig. 4, g and h are both acceptable representations of a species of poisonous snake (*kwa*). Fig. 4g is the minimally necessary representation, which may be expanded within the borders, as in Fig. 4h. Should there be differential fill in the elements[52] of a *kwa* design (Fig. 4g), the viewer may identify *ŋōrā* (Fig. 4n or o – leather strips on which cowries are sewn). With regard to *ŋōrā*, Fig. 4n and o are allomorphs and the differential placement of fill is irrelevant to meaning. Should the elements of the *ŋōrā* design be expanded within the borders, however (such as was done with the *kwa* example above), the result may be identified as an anteater species, a *karaca* (Fig. 4p or q). A *karaca* representation, in order not to be confused with *ŋōrā*, must have at least four series of element repeats.

Fig. 4i and j are allomorphic variations of a python species (*wōm*) in which the double row of spots may be oblique or perpendicular to the border and still constitute an acceptable representation. The *wōm* cannot have fewer than two rows of spots, however, or it becomes a representation of the *ten* species of poisonous snake (Fig. 4d). If it has more than two rows of spots, it risks identification as one of the several cat species, such as *tūrka tera* (cf. Col. pls 3, 11), or *tūrka tōrē* (Col. pl. 9).

Not all possible variations are allomorphic or constitute other representational designs. Fig. 13b and c are both meaningless designs (although not uncommonly seen). Neither is an appropriate representation of the *kapergēt* species of poisonous snake (a type of cobra – Fig. 4b), which must have at least a triple declining repeat of the design elements – no more (Fig. 13c) and no less (Fig. 13b).

The degree to which curve is a semantic variable can be seen in contrasting the *dēŋa pōrpōrla* (Fig. 4a) with a meaningless, but common, design, Fig. 13a. Similar attention to precision in execution and orientation of elements can be seen in comparing the *nyōr* poisonous snake (Fig. 4c) with the *dēŋa amgōsēa* species (Fig. 4e). The semantic discrimination here is based solely on the perpendicular *v.* oblique orientation of the element to border (a criterion irrelevant in Fig. 4i and j, the *wōm* allomorphs, but critical to the distinction between *karaca* – Fig. 4p and q, and *kerdaker* – Fig. 4r). The same variable is significant in the case of rain (*kēō* – Fig. 4s), which cannot be meaningfully represented by either Fig. 13d or Fig. 13e – designs commonly seen but meaningless. The semantic difference between *dēŋa nyōr* and *kēō* (a species of poisonous snake and rain, respectively) is simply the presence (Fig. 4c) or absence (Fig. 4s) of a border on one side.

If we compare the various representations of Table 8 in similar manner, it requires but little time to begin to see critical minimal discriminations. A species of anteater (*karaca* – Fig. 4p and q) differs from small tortoises (*kerdaker* – Fig. 4r)

a	b	c	d	e

Figure 13
Non-Representative
Linear Designs
(see also Fig. 4)

only in the oblique *v.* perpendicular orientation to the border, and thus any attempt to specify the processes in identification and/or production of the representative design universe must consider this variable – perhaps with a skewing rule.

In a similar manner, any generation or identity rules must include an operation or recognition factor for fill. The distinction between mountains (*cada* – Fig. 4k), breasts (*cū̱ṯẖō* – Fig. 4l), and Shilluk necklaces (*gaṇ* – Fig. 4m) is in the fill – between Fig. 4k and l in the presence or absence of fill, and between these and Fig. 4m, the type of fill. As mentioned, alternative fill components also mark one of the distinctions between *dḗṇā kwa* (Fig. 4g and h) and *ŋ̄ōrā* (Fig. 4n and o), and between one allomorph of *dḗṇā kwa* (Fig. 4h) and *karaca* (Fig. 4p and q). The differential placement of fill is not relevant to *ŋ̄ōrā* identification, however, as Fig. 4n and o are allomorphs.

An examination of the feature codes for several designs of *Type 3b* (see Table 8)[53] reveals further minimal semantic contrasts. Colour contrast is clearly one, with – in the case of *tōmā* (spotted) design types (see Table 6 and Fig. 6e) – size of spot and proximity of spots also constituting relevant distinctions. For those designs coded by stripes (*pacōrē* – see Table 6 and Fig. 6d), colour contrast, length, size, number and orientation of stripes also constitute critical semantic variables.[54]

The framed and bordered designs (*Type 2*) form 'stripes' on the body, and could thus be analysed as variations or special types of *pacōrē* (striped) designs. I have not treated them as such, however, for meaning in the case of the bounded *Type 2* designs rests in sufficient linear extension of critical elements within borders for correct identification – whereas with the striped designs of *Type 3b* it is the parallel repetition of sufficient of the appropriate stripes themselves which is necessary for positive identification. In both types of representations the minimal number of element repeats necessary to constitute a meaningful design is at

least four (cf. Pl. 6). That is, fewer than four element repeats of linear extensions in bordered designs elicit ambiguous responses as to identification, and fewer than four spots or four parallel stripes in designs of *Type 3b* appear to be insufficient for positive identification. It is thus significant that the *dōŋeraŋ* bird (Fig. 7g), coded by vertical stripes on the face, is defined by four parallel repeats. For the same reasons, the *ŋair* and *taliŋl* representations (Fig. 12j and Fig. 7d, respectively) are no more than three parallel stripe repeats – four or more would result in different representations or ambiguous identification. And it is possibly also significant that stripe width and spot diameter never exceed three-finger thickness in size – four or more finger thickness results in entirely different designs, most of which are not meaningful (cf. Pls 7 and 46 – both non-representative designs with stripes exceeding three-finger width in thickness).

There appear to be, then, several semantic dimensions with which designs of Table 8 can be identified. These are colour contrast, element curve, element-border relationship, element spacing, size, width, fill and orientation. It should be clear that these semantic dimensions are not in themselves minimal aspects or units of meaning. Each dimension is but an axis along which meaning shifts, and meaning emerges on each dimension when (and only when) in appropriate combination with specific values along at least two other axes or dimensions. These dimensions, then, can be considered operators on which operations may take place – operations which are expressions of relationship, not irreducible units of meaning.[55]

Indeed, a search for minimally meaningful units more fundamental than the representational design forms themselves in a graphic system such as the Southeastern Nuba is, as has been shown, fruitless – like searching for the 'meanings' of phonemes, as it were. It is the catalogue of critical distinctions between meaning – the relationships – that we seek, not irreducible units of meaning. I could elicit few reactions for graphic units of Fig. 14. This exercise

a b c d e f

Figure 14
Non-Representative
Graphic Elements

may not be a waste of time in other situations, for there is some evidence that there may be representational systems posited on such minimal units of meaning (cf. Munn, 1966). Southeastern Nuba art is phanetically complex, however, and their responses to less-graphically complicated elements are markedly un-Freudian.

It should be apparent from Table 8 that a componential analysis is possible – that is, it is possible to specify componentially the distinctive values of each

representation. This would be a type of shorthand to the feature codes of *Type 3a* and *3b* designs, and a verbal componential specification of the *Type 2* designs. Each semantic dimension can be seen to have several values, and the componential definitions would specify one of these values for each relevant semantic dimension. I initially analysed the representative design corpus of Table 8 componentially,[56] but it became clear that however interesting this might be, there was nothing of significance to be said (from a formal point of view) about a set of sixty-odd designs, essentially cross-classified in terms of attribute values about seven or eight semantic dimensions (cf. Chomsky, 1968:65). And from Miller's work (1956) we have known for some time something of the limitations of human ability to process information – where eight to ten features constitute a maximum number along which we are normally able immediately to categorise at least binary values.

It seemed more productive to consider the graphic set as analogous to a language or a more complex information processing system (Watt, 1966; 1967; Geoghegan, 1968). It becomes possible, then, to consider the semantic dimensions not simply in componential terms, but in terms of sequential decisions affecting the generation of phrase structures (expressions). Further ordered operations act as transformational rules on these phrase structures – inhibiting the generation of unmeaningful forms (sieving transformations) or expanding the phrase structure expressions into some final realised form on the body (expansion transformations). The aesthetic rules discussed in the previous chapter can be considered one general type of inhibiting transformation.

It is possible to express this generative sequence algorithmically. The format is explicitly mathematical in character, and has immense advantage over other taxonomic and componential approaches.[57] This algorithm is exhibited in Table 9. It has been designed for potential machine production, as the morphology is relatively simple and the universe small. Every operator may be regarded as a semantic variable which any fieldworker could easily determine. They are not arbitrarily derived, and at least one operation possible for each operator reveals a minimal difference between representations.

THE GENERATIONS

Each generation must operate with an element. These are simple linear forms (but unlike lines, these linear forms are here defined as having width) on which operations occur. The elements used in the generation of the designs of Table 8 are illustrated in Fig. 15 below. I have oriented the algorithm to deal with one of five elements, but this could be reduced to no more than three – the use of five elements here is simply to reduce the number of operations necessary in the generation of initial phrase expressions.

(for design, see Table 7, p. 92, *Type 2, 3a, 3b*)

FORMAT

Instructions	*operators*	*operations*

A. Choose portion of body
B. Choose element (Fig. 15)
C. Design generation:
 begin sequence

 1. *Colour*
 (colour of execution of
 design/background colour)
 all subsequent operators
 operate with element
 choice, acting on colour
 with capital letter.

 Any colour/any other colour;
 Black/white; Black/yellow;
 White/black; Yellow/black;
 Red/any other colour.

to next operator

 2. *Horizontal*
 (operation left to right)
 all subsequent operators
 act on expression thus
 far generated.

 Element is:
 JUXtaposed horizontally;
 CONnected horizontally:
 JUXtaposed horizontally,
 ADJacent element REVersed;
 CONnected horizontally,
 ADJacent element REVersed;
 SKIP.

to next operator

 3. *Vertical*
 (operation down-up)
 all subsequent operators
 act on expression thus
 far generated.

 Element is:
 JUXtaposed vertically;
 CONnected vertically; JUX-
 taposed vertically, ADJacent
 element REVersed; CONnected
 vertically, ADJacent element
 REVersed; SKIP.

to next operator

 4. *Frame*
 (vertical straight line)
 operator acts at maximally
 extended horizontal member
 of expression thus far
 generated; extends verti-
 cally for duration of
 expression: all subse-
 quent operators act on
 expression thus far
 generated.

 JUXtaposed Right; JUXtaposed
 Left; JUXtaposed Right, Left;
 CONnected Right; CONnected
 Left; CONnected Right, Left;
 SKIP.

to next operator

5. *Fill*
 (operator acts on
 enclosed space only)
 all subsequent operators
 act on expression thus
 far generated.

 SOLid fill; DESigned fill;
 SKIP.

to next operator

6. *Expansion*; *Reduction*
 all subsequent operators
 act on expression thus
 far generated.

 EXpand expression VERtically
 (1 FINger; 2 FINger; 3 FIN-
 ger); EXpand expression
 HORizontally (1 FINger; 2
 FINger; 3 FINger); EXpand
 expression VERtically,
 HORizontally (1 FINger; 2
 FINger; 3 FINger; WHole HAnd);
 REDuce expression within
 OUTline; SKIP.

to next operator

7. *Repeat*
 (horizontal operation
 left to right, vertical
 operation down-up, dia-
 gonal operation left to
 right, up and down)

 REPeat, JUXtapose DIStance =
 to extension of expression
 (VERtically; HORizontally;
 VERtically, HORizontally;
 DIAgonally); REPeat, JUXtapose
 DIStance < extension of
 expression (VERtically;
 HORizontally; VERtically,
 HORizontally; DIAgonally);
 REPeat, JUXtapose DIStance >
 extension of expression
 (VERtically; HORizontally;
 VERtically, HORizontally;
 DIAgonally).

Stop

Symbols: ;= or ('or else')
 ,= and ('and also')
 /= unlike, disjunction ('not same as preceding')
 .= end of operation, proceed to next operator

Figure 15
Phanetic Elements
(for productions of
generative algorithm,
Table 9)

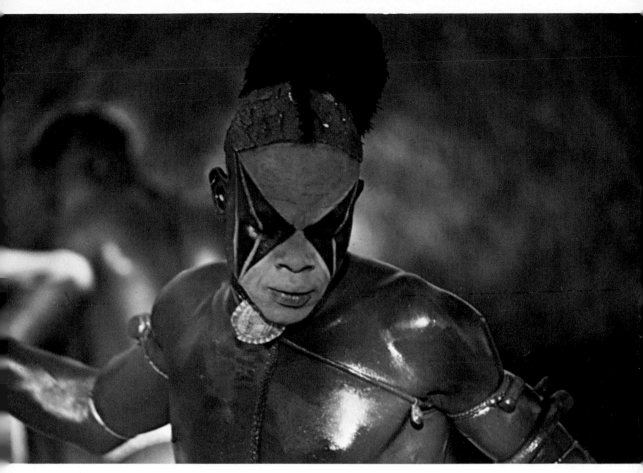

Colour plate 26
Variation of *cipaliṇ* facial design, ostrich plume
attached to *r̠ūm*. *Kadūndōr* prancing at *nyertuṇ*

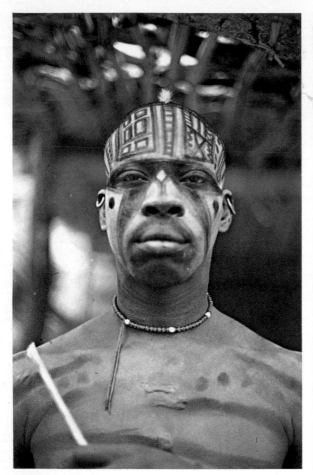

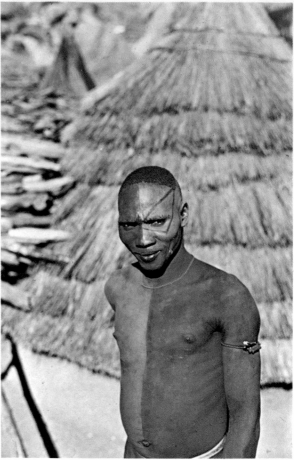

Colour plate 27
Balanced forehead design, the facial design
oriented about nasal dip

Colour plate 28
Tōrē design in red and yellow. Note the facial
design

These elements can be expressed mathematically, and equations about a coordinate system can easily produce these elements.[58] I do not know, in fact, whether this format is capable of being programmed with current computer languages, though there seems no reason why it cannot be. This perhaps links phanetic researches[59] to the development of new machine languages.

Rather than illustrate the generations for all the designs,[60] I have selected several different examples to indicate how the algorithm is used. After study of the examples given, it should be clear how all other designs are generated.

GENERATION EXAMPLES

No. (from Table 8)	Designata	English approximation
1.	*dēn̥ā pōrpōrla*	poisonous snake *sp.* (Fig. 4a)

Generation (cf. Table 9)
A. Anatomically general (*Type 2*)
B. Element III (Fig. 15)
C.

1→ A/a
2→ SKIP

$$3 \rightarrow \int_{4}^{\infty} \text{CON ADJ REV}$$

4→ CON (R+L)
5→ SKIP
6→ SKIP
7→ SKIP
Stop

| 12. | *n̥ōrā* | cowrie shells on leather strips (allomorph n, Fig. 4) |

Generation (cf. Table 9)
A. Anatomically general (*Type 2*)
B. Element II (Fig. 15)
C.

1→ A/a

$$2 \rightarrow \int_{0}^{2} \text{CON ADJ REV}$$

$$3 \rightarrow \int_{4}^{\infty} \text{CON}$$

4→ SKIP
5→ SOL

(go back to operator 4 and repeat sequence on expression thus far generated)

4→ CON (R+L)
5→ SKIP
6→ SKIP
7→ SKIP
Stop

12. *ŋōrā* cowrie shells on leather strips
 Generation (cf. Table 9) (allomorph o, Fig. 4)
 A. Anatomically general *(Type 2)*
 B. Element II (Fig. 15)
 C.

 1→ A/a
 2→ SKIP

$$3 \rightarrow \int_{4}^{\infty} \text{CON}$$

 4→ CON L
 5→ SOL

 (go back to operator 2 and repeat sequence on expression thus far generated)

$$2 \rightarrow \int_{0}^{2} \text{CON ADJ REV}$$

 3→ SKIP
 4→ SKIP
 5→ SKIP
 6→ SKIP
 7→ SKIP
 Stop

16. *krā* chipmunk-like forest rodent *sp.*
 Generation (cf. Table 9)
 A. On back *(Type 3a)*
 B. Element I (Fig. 15)
 C.

 1→ B/y
 2→ SKIP

$$3 \rightarrow \int_{0}^{\infty} \text{CON}$$

 4→ CON R
 5→ SOL
 6→ EX HOR I FIN

$$7 \rightarrow \int_{4}^{\infty} \text{REP JUX DIS} = \text{HOR}$$

32. *tūrkā tera* leopard *sp.*
 Generation (cf. Table 9) (Col. Pls 3, 11)
 A. Anatomically general *(Type 3b)*
 B. Element III (Fig. 15)
 C.

 1→ B/w

$$2 \rightarrow \int_{0}^{2} \text{CON ADJ REV}$$

$3 \rightarrow$ SKIP
$4 \rightarrow$ SKIP
$5 \rightarrow$ SOL
$6 \rightarrow$ EX (VER+HOR) 1 FIN

$7 \rightarrow \int_{4}^{\infty}$ REP JUX DIS $=$ (VER + HOR)

Stop

37. *daṇ ka fellata* cow (Fulani type)
 Generation (cf. Table 9) (Pl. 13)
 A. Anatomically general (*Type 3b*)
 B. Element III (Fig. 15)
 C.

 $1 \rightarrow$ B/w

 $2 \rightarrow \int_{0}^{2}$ CON ADJ REV

 $3 \rightarrow$ SKIP
 $4 \rightarrow$ SKIP
 $5 \rightarrow$ SKIP
 $6 \rightarrow$ EX (VER+HOR) 1 FIN

 $7 \rightarrow \int_{4}^{\infty}$ REP JUX DIS $=$ (VER + HOR) $\left[\left(\int_{0}^{1} \text{JUX DIS} < \text{HOR} \right) \right.$
 $\left. \left(\int_{0}^{2} \text{JUX DIS} < \text{DIA} \right) \right]$

 Stop

41. *krendelnya* giraffe *sp.*
 Generation (cf. Table 9) (Col. pl. 2, 12)
 A. Anatomically general (*Type 3b*)
 B. Element III (Fig. 15)
 C.

 $1 \rightarrow$ B/y

 $2 \rightarrow \int_{0}^{2}$ CON ADJ REV

 $3 \rightarrow$ SKIP
 $4 \rightarrow$ SKIP
 $5 \rightarrow$ SOL
 $6 \rightarrow$ EX (VER+HOR) 3 FIN

 $7 \rightarrow \int_{4}^{\infty}$ REP JUX DIS $=$ (VER + HOR)

 Stop

51. *ṇer* zebra
 Generation (cf. Table 9) (Pl. 9)
 A. Anatomically general (*Type 3b*)
 B. Element V (Fig. 15)
 C.
 1→ W/b

 2→ \int_{0}^{∞} CON

 3→ SKIP

 4→ SKIP

 5→ SOL

 6→ EX VER 2 FIN

 7→ \int_{4}^{∞} REP JUX DIS = VER

 Stop

60. *kamūlaṇ* hyena *sp.*
 Generation (cf. Table 9) (Pl. 21)
 A. Anatomically general (*Type 3b*)
 B. Element V (Fig. 15)
 C.
 1→ B/y

 2→ SKIP

 3→ SKIP

 4→ SKIP

 5→ SOL

 6→ EX VER 1 FIN + EX HOR 2 FIN

 7→ \int_{4}^{∞} REP JUX DIS = VER (DIS < HOR)

 Stop

62. *wēā kōra* wasp *sp.* (small)
 Generation (cf. Table 9) (Pls 6, 37)
 A. Anatomically general (*Type 3b*)
 B. Element V (Fig. 15)
 C.
 1→ B/w

 2→ \int_{0}^{∞} CON

 3→ SKIP

 4→ SKIP

 5→ SOL

 6→ EX VER 1 FIN

106

$$7 \rightarrow \int_{4}^{\infty} \text{REP JUX DIS} = \text{VER}$$

Stop

A discussion of the examples above should make clear the generations. From Table 8, the first example is a poisonous snake species, *dēŋā pōrpōrla* (Fig. 4a), and the generation is simple. Instruction A (Table 9) is irrelevant, as this design can be placed anywhere on the body. It is generated, however, vertically, for format convention. Element III is chosen (Fig. 15c) in any aesthetically appropriate colour contrast. The horizontal operator is skipped, and the vertical operation involves repeating, from a minimum of four times to an infinite number of times, a connection of the phrase expression ⊂ to itself, with the adjacent expression reversed ⋛ . The framing operation connects both left and right vertical straight lines on the maximal horizontal extension of the phrase structure thus far generated ⫚. This is sufficient for recognition of the appropriate design, and all subsequent operators are skipped.

The generation of other *Type 2* designs is slightly more complex. One accept-able representation of *ŋōrā* (cowrie shells on leather strips – Table 8, No. 12) is illustrated in Fig. 4n. This generation is anatomically general (though by format convention produced vertically) and thus instruction A is irrelevant. Element II (Fig. 15b) is chosen, in any aesthetically acceptable colour contrast, and is first connected to itself, horizontally, with the adjacent element reversed ∘. The vertical operation simply connects, from four to an infinite number of times, the phrase structures thus far generated ⅜. The framing operator is here skipped, and the fill operator acts on a solid command (filling all enclosed space ⁝). At this point all remaining operations may be skipped, and the entire algorithm begun again with the phrase structure thus far generated. I have introduced a special command, however, to eliminate repetition, which requires that the phrase expression thus far generated is returned in the format to the framing operation. This adds both left and right vertical straight lines, thus completing the design ⫴.

The other allomorph of this representation, Fig. 4o, is generated in a somewhat different manner. Again ignoring Instruction A, and choosing element II (Fig. 15b) in any aesthetically acceptable colour contrast, the horizontal operator is at first skipped. The vertical operator connects the phrase structure (still element II at this point) to itself from four to an infinite number of times ⅜ . Then a framing operation occurs on the left side only of the phrase expression ⎸ at the maximal horizontal extension, resulting in, should it have been sought, an acceptable representational design, *cūt͟hō* (breasts – Table 8, No. 10, and Fig. 4l). Then a fill operation fills the enclosed areas solidly (becoming, were it sought,

107

an acceptable design of mountains (*cada* – Table 8, No. 9, and Fig. 4k,⎮).
As in the previous example a special command is introduced here to prevent
repetition, and the phrase structure thus far generated is returned to the horizontal
operator. Here the expression is connected to itself with the adjacent phrase
expression reversed ‖. This completes the design and the rest of the operations
are skipped. The distinction between the generation of this design and its
allomorph stems solely from the differential placement of fill. Using the ele-
ments available it required different production strategies, though with elements
reduced to equations the generations would be much more elegant.

The generation of the following *Type 3a* representational design reveals further
inelegance in the algorithm. For a chipmunk-like forest rodent species (*krā* – see
Table 8, No. 16), Instruction A should read *On Back*. Using element I (Fig.
15a) in black on a yellow background, the horizontal operator is skipped.
Vertically the phrase structure (still element I) is connected to itself an infinite
number of times. This results in a phrase expression which could be a representa-
tion for rain (*keō* – Fig. 4s; Table 8, No. 15 ‖). The framing operation con-
nects a vertical straight line to the right of the phrase structure, resulting, should
it have been desired, in a representation identifiable as *deṇā nyōr* (Table 8, No.
3; Fig. 4c ‖). The fill command is solid, which, as it acts on all enclosed
spaces, results in a solid vertical band. It is here that the algorithm exhibits lack
of elegance, and the persistent reader can probably find several other ways of
generating a similar phrase structure. The expression thus far generated is
expanded horizontally to one finger thickness, and it is repeated from four to an
infinite (the limits of the space for design here being defined as the back) number
of times, juxtaposed to itself at a distance from itself equal to its horizontal
extension – that is, solid vertical black bands of one finger width parallel to
each other at a distance from each other of one finger width.

Type 3b designs, like those *Type 2* designs discussed above, are also anatomi-
cally general. A leopard species, *tūrkā tera* (Table 8, No. 32 – see also Col. pls
3, 11) carries the feature code of 'more than four 1 fingertip B/w spots, close,
ungrouped' – a morphological description reasonably congruent with the
design production and graphic morphology. For its generation, anywhere
(or all over) on the body, element III (Fig. 15c) is chosen, in black on a white
background, and the horizontal operation involves connecting the element to
itself with the adjacent element reversed. As element III is given with the
opening left, a command to connect an adjacent reversed element will result in a
circle (○). No vertical operations are used, no framing operations (as were
typical of *Type 2* designs above). The next operation, fill, acting on the enclosed
space of the phrase expression with a solid command, results in a solid circle ●.
The expansion operation involves expanding this phrase structure, in both verti-

cal and horizontal directions, to the size of one fingertip. This expression is then repeated, from a minimum of four times (as at least four fingertip-sized spots are necessary for identification) to an infinite number of times (covering the body), juxtaposed – the distance between the expressions being equal to at least their own diameter, in both horizontal and vertical directions. This results in an acceptable *tūrkā tera*.

A slightly more complex *Type 3b* representation is a Fulani cow type, *daŋ ka fellata* (Table 8, No. 37 – see also Pl. 13). The generation of the phrase structure (ɔ) proceeds exactly as in the previous example. The fill operation is, however, skipped, as the phrase structure remains 'hollow' (this is executed by stamping on the body, using a hollow grain stalk approximately one fingertip in size which has been dipped in black ash). The expansion operation is as in the previous example – expansion in both vertical and horizontal directions to the size of one fingertip – but the repeat operation is complex.[61] Operating on the phrase expression thus far generated o, a like expression is juxtaposed to it horizontally at a distance from it less than its own diameter, i.e., oo. A simultaneous diagonal juxtapositioning of two like expressions occurs, each (both up *and* down – the algorithm must specify this in order that ambiguity does not result) at a distance from it less than its own diameter, i.e., ⊕. A combination of these two operations result in the phrase structure ⊕, which *as a whole* is repeated from a minimal number of four times to an infinite number of times, juxtaposed both horizontally and vertically to itself at a distance equal to itself.

The other generation samples involve but slight variations in execution from those discussed above – variations which a reader can easily follow, and further discussion would be repetitive.

SOME IMPLICATIONS OF THE ANALYSIS

Table 9 is essentially an iconic or picture grammar (or more specifically, a morphology).[62] The morphology is generative, with context-free phrase structures (expressions) on which operators act, some of which may be interpreted as transformational. Several features of the system are worth further comment.

First, it should be clear that the algorithm (Table 9) can be used to generate common non-representational designs. Those designs of Fig. 13, for example, can be easily generated. In the case of Fig. 13a (see Pl. 38 – left upper chest):

 A. Anatomically general
 B. Element II (Fig. 15)
 C.

 1 → A/a
 2 → SKIP
 $3 \to {}_0\!\int^{\infty}$ CON

```
4 → CON (R+L)
5 → SKIP
6 → SKIP
7 → SKIP
Stop
```

Many other non-representative designs are also possible.[63] Cultural agree-
ment about feature attributes of meaningful representations is, then, precise and
narrowly defined. This could have only come about through a long and persis-
tent evolution in circumstances of little change affecting the art tradition.

There are other evidences from the analysis which indicate a highly evolved
and precisely defined system. In the representative designs characterised by spots
or stripes (*Type 3b* and some of *Type 3a*), there is an approximation of what
might be called a 'saturated set' – that is, many of the possible colour contrasts
are exhausted with the one-finger width, two-finger width, and three-finger
width striped designs, respectively, and with the fingertip and heel of hand
(three finger) sized spotted designs respectively. The degree to which actual
representations account for the corpus of all possible productions (given the
variables of the algorithm) is some measure of 'saturation'.

The striped designs appear to be more 'saturated' a set than the spotted design
representations, perhaps because other graphic variables, such as grouping
and solid (or no) fill, are relevant to spotted designs but not to striped designs.
If 'any colour/any other colour' is considered one contrast, a simple table (Table
10) indicates that striped design representations in fact account for fifteen cells
of a possible thirty – one-half of all possible designs, then, using the semantic
operations of the algorithm, in fact bear meaning. This is the closest any 'set'
comes to semantic 'saturation' of those designs possible when all possible de-
signs of the 'set' are generated. It might appear that this is an analytical point,
but the idea of 'set' is implicit in the design form types of Table 6 (Fig. 6) –
which govern all designing. Designs of the striped 'set' are in fact *pacōrē* (Table
6c, Fig. 6d), whereas those of a spotted 'set' are *tōmā* (Table 6d, Fig. 6e).

To increase width of stripes as another possible semantic alternative is not
possible (see above, p. 99), as more than four-finger width stripes, while
aesthetically acceptable, are not part of the representational universe. Unless
existing non-representational designs are to take on meaning and the feature
definitions be expanded for these semantic operations, it is difficult to see how
the corpus of representations coded exclusively by surface characteristics can
expand very much. The 'saturated set' seems to have implications for the
evolution of the representational design system – a process now lost.[64]

It is also for these reasons that I am satisfied that I probably saw most of the
representational designs coded at least in part by surface characteristics (*Type 2,*

TABLE 10: *Representational striped designs v. striped designs possible*
(based on variables used in algorithm, Table 9 – numbers from position on Table 8)

vertical stripe / horizontal stripe	1 finger width	2 finger width	3 finger width
W/b	50 *umuth*	51 *ṇer*	53 *ānē*
B/w	17 *nyerwōn* 62 *wēā kōra*	63 *wēā patʔtra*	65 *wathen*
B/y	16 *krā* 58 *lā*	59 *wōrlth*	61 *wōrtha*
Y/b	18 *wūtrū* 54 *ṇbōr*	55 *tagōkē*	57 *lulpin*
A/a			

3a, 3b) which occur, and have some assurance that the universe analysed here is reasonably complete. I queried many designs for meaning during the period of fieldwork,[65] and the limitations of the sets became clear quickly. I could efficiently check and query for variations along specific dimensions once I began to have an idea of the 'grammar' of surface-coded representational designs, so in all likelihood the corpus discussed here is most of the existing universe. Those semantic representations coded by shape, of course, have potentially unlimited freedom of expansion (see above, p. 91).

I have suggested repeatedly that the choice of species for representation rests with the appeal of its surface manifestations. This, of course, is not the sufficient factor in the choice of natural species for representation, even if a necessary factor. Reasons for choice of natural species beyond this, however, are lost, and probably rest in areas of perception, conception and graphic information processing about which we know little (see note 64, p. 122). And I have stressed that supernatural and culturo-symbolic factors are of little or no consequence in the choice of species for representation.

The corpus of designs exhibits several other interesting features – some of which have cultural implications, but others are undoubtedly suggestive of fundamental aspects of human cognition. It is remarkable, for example, that the representative graphic system (particularly of animal species) manifests such a lack of redundancy. An animal species coded by its surface characteristics (*Type 3b*) is not coded (at the species level) by its shape morphology (*Type 1* designs), and vice versa, even though it is possible that they could be redundantly coded, since many of them have unique surface characteristics as well as unique shapes. They are coded in personal art, however, by *either* shape *or* surface – not in two different ways. The only exception to this is the *wōriṇ* forest antelope species (Table 8, No. 29) which is coded by *both* its facial characteristics (see Fig. 12c) *and* by its unique horn shape (see Fig. 8c), or even, in one case I saw, by both (see Fig. 9).

Two giraffe species, the *dūn* (Table 8, No. 35, and Col. pl. 1; Pl. 48) and the *krendelnya* (Table 8, No. 41, and Col. pls 2, 12), are both coded by surface characteristics. Generally, however, giraffes may be graphically coded by shape morphology (generically also labelled by the term *dūn*), as in Pl. 20.[66] Taxonomically, then, the graphic coding/lexical coding situation is:

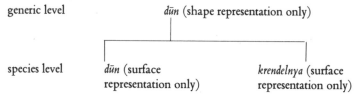

Just as we have information about covert categories (or lexical blanks – cf. Berlin, Breedlove and Raven, 1968; and Faris, 1968b) in lexical taxonomies, so is it that covert categories or graphic blanks are found in representational design systems. Ostriches, for example, are coded both in shape, at the generic level (see Col. pl. 24; Pl. 13 [eyes]), and by surface characteristics at the species level (see *kūṇgūrū ka lelṛ*, No. 27, Table 8; Pls 16, 26, and Fig. 7c). But a 'graphic blank' exists where there is a lexical label at the species level for another ostrich, *kūṇgūrū merēʔēl*. Taxonomically:

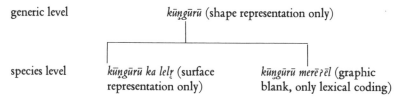

To some extent the information about each species carried by its label compensates for the 'graphic blank' – *ka lelṛ* may be translated 'of the legs' – referring to

the feature of this species which is graphically coded in the design system; in contrast to *merē ʔēl*, which may be translated 'smooth', referring essentially to the absence of the feature used to graphic code the other species – i.e., without stripes on its legs.

The above illustrates the lack of redundancy in the representational design system, even though some representations are coded by surface characteristics, while others are graphically coded by shape characteristics. The random occurrence and arbitrary distribution of 'characteristics' in the natural world is overcome in the representational design system where the classification of the world is represented in a remarkably elegant and efficient manner. Related to this is the point that in those representational designs coded at least in part by surface characteristics (*Types 2, 3a, 3b*), in every case the coded natural species is a minimal level taxon – it is a species designation rather than a generic designation – although higher level taxa (generic) may be design coded by shape. In some cases I suspect that the graphic representations themselves are more detailed than the lexical classifications of Western biologists – as, for example, in the several leopard species of Table 8. Not having seen most of these, of course, I cannot say. In other cases, unique variables for lexical classification are manifested in the graphic system – as with the *krā* and *nyerwōn* (Nos. 16, 17, Table 8, respectively), two chipmunk-like rodent species, whose differential habitats (forest and village, respectively) are marked graphically (in the B/y stripes and B/w stripes, respectively).

CONCLUSIONS

This book has been an attempt to document and analyse the personal art tradition of the Southeastern Nuba. I have commented on the functions, forms and content of the art, its probable evolution and adaptation, and the factors which were likely to have contributed to this. The context, both synchronically and diachronically, both social and cultural, has been considered as far as it is possible to do so.

It has been shown that paramount to transmission of any semantic message in personal art are the series of aesthetic and form dictates which ensure the proper emphasis and concentration of the prepared body. In this concern with style and form, principally for aesthetic reasons (as opposed to functional, symbolic or ritual reasons), the Southeastern Nuba art tradition is unusual. The principal exercise is the celebration and exposure of the strong and healthy body. And it is probably in this concern with health that we find the material origin of the art tradition.[67] A paramount emphasis of this study is that aesthetics stem from material origins and are not independently-existing ideas.

These aesthetic constraints and rules of form can also be regarded as aspects of a type of syntax – transformational rules allowing productions judged on 'well-formedness', and inhibiting 'ungrammatical' constructions. This becomes clear when considering the final chapter – where the morphology and phanemics of the representative designs are worked out, and it is shown that they must be chanelled through the rules of form to realisation on the body.

114

The last chapter illustrated the structural logic relevant to representational designs coded at least in part by surface characteristics of the natural species represented. This has not been a 'structural logic' similar to that normally elucidated for tribal art traditions (cf. Lévi-Strauss, 1963a – a heritage stemming from art history and stylistics, which, although frequently using analogies to language, emphasises only vague and metaphorical relationships to scientific linguistics), but leaning on transformational and generative grammatical work and recent iconic researches, I have sought to deduce a series of operations about elicited semantic variables which enable identification and production of the corpus of representative designs discussed. These semantic variables and operations on them are reasonably economical and generate all possible productions – they reveal a series of ordered sequential decisions necessary and sufficient for this generation. The analysis is formal, but it is tempting to suggest some cognitive validity, for each sequential operator is posited along precise semantic dimensions, and the total is restricted in number – within bounds well known to limit human information processing capabilities (Miller, 1956).

I do not think Southeastern Nuba surface-coded representations are unique in the world. It would seem that many other natural systems – that is, indigenous graphic sets with meaning – such as hieroglyphics or other folk-design systems with semantically meaningful components, could be treated in a similar manner. Recent work (see above, p. 8) indicates that this orientation is fruitful for other closed form systems, even if semantic meaning is lost. In the speculative concern with function (particularly ritual and symbolic function), however, the structure and rules for identification and generation of the graphic sets themselves have heretofore been ignored.

Perhaps more work with indigenous art traditions along the lines suggested in this volume will enable us to make more general statements on graphic systems, visual conceptions and discriminations. This will hopefully lead to the establishment of iconic universals, and enable us to make meaningful statements on the relationships of signifier to sign, and sign to symbol – which have unfortunately been so irrevocably divorced in this century for there can be little progress in the scientific study of symbol systems, such as art traditions, until the material base in productive social relationships is specified.

NOTES

PREFACE

1. The art tradition is, of course, practical activity in the sense that it has a material base. This base, however, concerns the celebration and symbolism surrounding the healthy, strong and youthful body (see below, p. 114) – not practical activity in the sense of functional control.

2. From this it might be argued that Southeastern Nuba personal art is non-symbolic; most pictorial theories regard symbolisation and representation as mutually opposed (cf. Gibson, 1954). But this involves several thorny philosophical, psychological and perceptual problems, for Southeastern Nuba representational designs are not necessarily representational in the iconographic sense (Jakobson, 1965:23), and frequently it is not possible for persons alien to the culture to recognise the representation from the design. The psychological 'meaning' of designs (representative or non-representative) is another realm of potential symbolism – can Southeastern Nuba personal art be treated as a living Rorschach, so to speak (cf. Leach, 1954)? I queried briefly about more fundamental suggestions of particular design forms (see below, p. 99 and Fig. 14) and satisfied myself that the art tradition *per se* was manifestly not the result of any simple subliminal process, in either motivation or execution.

3. It is perhaps saddest to record that these analyses are encouraged and rewarded. In one example (an exchange over the interpretation of the design on a Trobriand shield – cf. Leach, 1954; Berndt, 1958; Leach, 1958), the editors actually solicited and appealed for such analyses (see Ed. note, Leach, 1958:79).

4. It was probably naïve of me to have considered the possibility of coincidence of taxonomic order and visually coded attributes of species beyond the trivial point that a graphic representation must represent at least one taxon. That most representations do, in fact, code minimal taxa, however (see below, p. 112), rather than taxa at more elevated (i.e., generic) levels in the taxonomy, is a more important point.

5. Previously, archaeologists and art historians have made use of linguistic models for the analysis of natural systems (cf. Knorozov, 1967; Dethlefson and Deetz, 1966; Kubler, 1969), but this has not been notably successful or widely accepted. The models were primarily of a parts-of-speech sort (Kubler), or specifically phonetic and morphological (Knorozov).

6. As Chomsky (1968:32) has demonstrated for linguistic production. Since we know something of the amazing abilities of the eyes (von Foerster, 1966:61), we can deduce similar complexity in visual coding processes and graphic production and identification.

CHAPTER ONE

7. Not to be confused with the census category *Southeast Nuba* of the *First Population Census of the Sudan, 1955–56*, which includes a far wider area and many more small unrelated hill groups. The Southeastern Nuba as considered here are the most southeasterly group of Nuba peoples, in the extreme southeast corner of Kordofan Province, at approximately 10° 30' N. and 31° 30' E. (see Map).

8. For data on the Southeast Nuba, see Nadel, 1950; and Faris, 1968a; 1969a; 1969b; 1970; 1971; forthcoming.

9. The 'Fungor cluster' of the Koalib-Moro language family – see Stevenson, 1956–1957; 1962; 1964; and Faris, forthcoming.

10. But see below, p. 123, note 67, for contrary speculation.

11. The situation of Jebel Werni is unusual, for normally the adoption of Islam is accompanied by various degrees of Arabisation, including patrilineal descent reckoning, inheritance and authority hierarchy (see Stevenson, 1966).

12. *contra* Nadel, 1950. See Faris, 1968a; 1969b.

13. The antiquity of the abandoned site on the plain is supported not only by oral tradition, but also by virtue of its location. The Southeastern Nuba moved to the mountaintop sites only after Arab migrations into the area and slave raiding. The indefensible plains site would indicate relatively little slaving – a situation that could only have existed before the Turko-Egyptian era (i.e., before 1820) or before the end of the Funj period when they held a portion of Kordofan for a few years (during the last half of the eighteenth century).

14. The Condominium government (Anglo-Egyptian) divided the Nuba Mountains into an Eastern and a Western section for administrative, educational and religious purposes (cf. Nadel, 1947). Christian missionaries established schools, missions, and dispensaries in the Western section, chiefly in the area of Kadugli (S.W.) and Heiban (N. Central). The Eastern Nuba Mountains section was to be left to the Government to provide health facilities, and religious instruction and education was to be in the hands of the Muslim *faqir* in Koranic schools. This meant that, as Islam was explicitly and implicitly discouraged in pagan areas, the people got no religious instruction *or* education at all (cf. Hurreiz, 1968).

15. The local 'chief' – a British-inspired adaptation from traditional Arab political organisation imposed on the acephalous Southeastern Nuba in line with policies of Indirect Rule. This post is always occupied by a man who is the traditional peace priest – a hereditary official responsible for ritual surrounding the maintenance of peace and success in war – and who is thus accorded respect and authority for certain decision-making. Today the priest's position – backed by the *omda*-ship – has wider sanctions which may be reinforced, if necessary, by force.

CHAPTER TWO

16. The irregular rainfall is principally due to micro-climatic features of the area. Essentially on the southern fringe of Nuba mountains, many of the wet clouds coming north pass over the Southeastern Nuba area to drop their moisture in the higher areas of central Kordofan. Explorers and travellers have long reported the area between the *Sudd* and the highlands of Kordofan as a land of thirst.

17. For one friend, whom I taught to read and write semi-phonetically, an entire new series of 'shapes with meaning' opened up, with which he frequently designed himself (see Pl. 5, which illustrates his name, 'Poba Aria' on his forehead). He knew the 'meanings' of these design forms, however, unlike others who simply copied the words as a design form in and of itself. Here, the 'representational' nature of the forms, semantically speaking, becomes a clouded issue. See note 26, below.

CHAPTER THREE

18. If it is a *cemţēŋen* infant – that is, if its birth follows on the death of an older sibling – then colouring matter is avoided until much later. For the very special treatment accorded *cemţēŋen*, see Faris, 1970.

19. Here again *cemţēŋen* children are distinguished. They retain a small tuft of hair at the base of the neck (see Fig. 2g) which is retained until shortly before puberty.

20. All clan memberships among the Southeastern Nuba, both matri- and patri-, are irrevocable from birth, unlike the Yako (Forde, 1965) or the Afikpo Ibo (Ottenberg, 1968) – both African societies characterised by duolineal descent and clan membership, in which patriclan membership may be changed.

21. A repeated factor for successful entry into the after-life among the Southeastern Nuba is proper diacritical marks, particularly body mutilations and hair grooming. This means certain extremes, such as *circumcision after death* for a certain patriclan section, and the necessary 'hair-grooming' death commemoration rituals practised by all patriclan sections (see Faris, 1971).

22. Or, for barren women, at a suitable time after consummation of the marriage.

23. Formerly, before pregnancy, young girls wore skirts of bark strips over their oil and ochre, but these are no longer used as they proved too flammable, and more than one girl lost her life when her bark skirt caught fire. Photographs of this type of skirt in use may be seen in Rodger (1955), who visited the area in the 1950s. Here is an instance of cultural change based on a material condition, without the influence of other cultures or outside agencies – a prime example of the fact that cultures, even in isolation, are not static.

24. To the patriclan sections of *lŗemtē*, *lŗkōra*, and *lŗemēŋ* (the patriclans characterised by red ochre), the talc white ritual colour is prohibited except at funerals (see below, p. 43).

25. It should be mentioned that, although not common, any older male can use the colours or hair fashions of his juniors – particularly of adjacent grades. The movement through the age system, then, can be regarded as the acquisition of new additions to the decorative repertory, not as changes requiring cessation of previously used materials. *Kadūndōr* or *kadōnga* men may be occasionally seen, for example, with *lōer* or earlier hair fashions (see Pls 22, 34, 35).

CHAPTER FOUR

26. An interesting aspect of the use of English word strings as design forms (see p. 19 above) is that they are produced on the body by artists *as they are seen* – so that I never saw ,STИUH NODИOⴙ or ⴙONDON ,HUИTꙄ; but rather the 'shapes' as they were seen. This involves an intriguing and remarkable perception and consequent adjustment in applica⸍tion, for commonly these word strings (as in Pl. 5, *Poba Aria*), are duplicated on the face, involving the use of mirrors, in which mirror images and their reversals have to be con⸍sidered.

27. An appropriate analogy is with non⸍vocal music – in the distinction between programme music and absolute music. The former relies on suggestive effects, conveying sensation, things, and eliciting responses relative to specific experiences – whereas absolute music is peculiar to a listener's aesthetic tastes, relying on tonal, stylistic, and rhythmic effects, and the listener's response to the internal structure of the music and its performance. Yet both to some extent have the same structure and partake of the same instrumentation and funda⸍mental organisational base. We cannot always be certain what a piece of programme music is supposed to suggest unless told so by the composer. So it is with much of Southeastern Nuba personal art.

28. Contrary to Central Australian art (Walbiri, Yiralla) where, so far as I can tell, the body is simply viewed as another surface on which to produce semantically meaningful art, just like a rock face or piece of paper (see Munn, 1966).

29. Of course, for the non⸍representational designs, these rules are the only relevant ones. For representational designs, they may act as transformational rules (see chapter seven).

30. Of course, with agricultural work – weeding, planting and harvesting – an elaborate body design would soon be obliterated. Still, those persons remaining in the villages – whose fields are sufficiently close to walk to and from each day – continue to oil, shave and groom their hair, and occasionally to decorate.

31. With this type of hair and oil symbolism, it is perhaps not difficult to imagine the local response to the ethnographer. I wore a beard during the field research, and did not shave or groom in any elaborate way. Not only was I white – a distasteful body colour – but I had hair on my arms, head and face which I didn't shave off. The community's behind⸍the⸍back name for me, in fact, became *wōtē* – a generic term for monkey.

CHAPTER FIVE

32. This initially caused me grief – for early in my research when I was still stumbling around in the language (no literature exists on the local language, and no one spoke any English), I thought *ēcēʔēt* must denote 'leaf', for both green leaves and yellow leaves were labelled by the same term. My own English colour vocabulary would never conceive yellow and green as being in any way common.

33. Since this research, the important book *Basic Color Terms* by B. Berlin and P. Kay (1969) has been published. The Southeastern Nuba colour terminology is a stage IIIb terminology in their scheme.

34. The shaving and grooming cycle is part of the diacritical attributes discussed above (see p. 21) as cultural indicators of rites of passage.

35. The design on this back is regarded as being poorly executed – principally because the balance is inadequate. A young boy did the work, and in his enthusiasm with the privilege, ignored aesthetic rules of symmetry and balance. There are no semantic violations, however.
36. In fact, Northwest Coast body and facial painting (cf. Swanton, 1908) is crudely developed and poorly executed in comparison with the magnificent art on material objects.
37. See Lévi-Strauss (1963a: 255) for a similar analysis of Caduveo facial art.

CHAPTER SEVEN

38. Though two of the five design form types are labelled with lexemes which have specific meaning, their use in this situation is polysemic, and the specific meanings (see Table 6) are not here denotata in the sufficient sense.
39. In this regard Southeastern Nuba personal art may be contrasted with many of the graphic systems from other parts of Africa and the world, where symbolic content assumes a more dominant place in the art – as, presumably, among the Ndembu of Central Africa (cf. Turner, 1967). The Southeastern Nuba are aware of the 'twofold source of artistic affect (Boas, 1955: 13)', but here the ideas associated with form are seldom allowed to dominate the concern with form.
40. This design is not an acceptable representation of the wōriṇ antelope. See Table 8, and Fig. 12c.
41. In this design the artist told me that the white dots above the eyes were in simulation of Shilluk facial scars (which are frequently painted white by Shilluk – see Col. pl. 17).
42. In contrast to Lévi-Strauss (1963a: 251 ff.) where designs are reported basically to obliterate body features, here designs are used in essence to enhance the body, to celebrate it by artistic-ally eliminating what is considered a flaw. In a highly speculative discussion, Lévi-Strauss (1963a: 255) suggests that the dislocation of body symmetry among the Caduveo and among Indians of the American Northwest involves an element of sadism and thereby erotic appeal. Although this seems to involve very questionable psychological associations, it should be emphasised that among the Southeastern Nuba any obliteration of natural symmetry or features is to enhance the body, not despise it (see above, p. 81).
43. The light/dark distinction in ṭōrē design form types may be on either side of the body – there are no aesthetic rules or symbolic restrictions peculiar to right/left orientations in Southeastern Nuba personal art (though there are a series of ideas regarding right/left orientations in other cultural domains).
44. It should be noted here that the red bird is outlined in yellow – red on black is not an appro-priate aesthetic contrast – perhaps because the contrast itself is insufficient, black and the deep red of ferric oxide both being colours of low brightness.
45. If perhaps the designed forehead in Pl. 30 can be termed 'gothic', then the forehead of Pl. 45 might be considered 'rococo'.
46. Pl. 49 does not illustrate an acceptable representation of a nyerwōn (see Table 8, No. 17).
47. I should mention that I have never seen total designs restricted to profile viewing as such – which is probably related to limitations in technique, particularly with facial designs, since the eyes are in the front of the head and mirrors are required to complete them. Only very rarely will one component of a design focus on profile alone.

48. It is important to stress that many of the shape-characterised designs are generic – that is, they stand for *classes* of natural objects and species for which more minimal lexical (and perhaps graphic) taxa exist (see below, p. 112), even though they are not normally expressed artistically. Designs of *Type 2* and *Type 3*, however, are in every case *species* of general classes for which there are no further lower level taxonomic distinctions, lexically or graphically. Not all species of a generic class, however, are necessarily coded in design representations, and there is, in short, no precise matching of lexical taxonomy and design (see above, n. 4).

49. These representational designs are coded by name only, and are not subject to the analysis presented below, but only to aesthetic constraints. They are similar to Watt's 'supercharges' (1966:111, 114) – designs for which the iconic generation rules are inappropriate.

50. These feature code glosses, though commonly unconscious and not frequently articulated verbally, are similar to blazons ('names', or verbalisations of distinctive features – i.e., descriptions, see Watt, 1966:15) of cattle brands (Watt, 1967:25), which 'translate' the brand. Like brand blazons, there is in the feature code glosses of Southeastern Nuba representational designs frequent ambiguity, and not all the information is available in the gloss itself. For some designs (those in which shape as well as surface is semantically relevant, i.e., *Type 2*) a verbalised feature code is not given, and a reproduction of the design itself is the most efficient description (see Table 8). Only for designs of *Type 3b* (and to some extent, *Type 3a*) are verbalised features codes possible. For Nevada cattle brands, the blazon is the description (Watt, 1966; 1967); for Southeastern Nuba representational designs, there is a name (the natural species represented), and it is normally possible to construct a feature code gloss (description) as well.

 There are several problems here which are still being worked out, and which, in any case, would not be of interest in the present study. These involve the nature of the iconic system itself – the feature codes and the extent to which they constitute a syndetic grammar – an appropriate set of rules for generation of both pictures and their associated descriptions – the degree to which two 'natural' languages share the same rules and are congruent.

51. Or, perhaps allophanes (from -*phane*: visible, manifest, apparent) – the term first used in iconic researches by Watt (1966). The use of linguistic terminology here is, of course, deliberate.

52. An element is here defined as a mark normally made with a single continuous stroke – that is, non-complex in execution.

53. For all designs of *Type 2* and some of *Type 3a*, the design itself is the most efficient representation – that is, a feature code would be very complex, if not impossible, and thus Table 8 requires that Figs 4, 12 and 7 be consulted.

54. The orientation of the *pacōrē* (striped) designs of *Type 3b* is limited to horizontal or near horizontal (i.e., not vertical). There is considerable variation (see Pl. 37), but if an approximation of vertical orientation results, there is the risk of confusing representations with several species of *Type 3a*, where vertical stripes on specific portions of the anatomy are necessary for identification, but where these are sometimes found on other parts of the body (at the convenience of the artist). Both vertical and horizontal stripes are *pacōrē* design form types.

55. There is an important methodological point – stressed time and time again in social anthropology (cf. Leach, 1961), but just as consistently ignored. Progress towards general theory (sufficient explanation) must be built on the examination of relationships, not things.

56. Presented in seminars in the Universities of London, Cambridge and Hull.

57. Compare, for example, the generative kin term analyses of Lounsbury (1964; 1964b) with the now-common componential analyses of kin terminologies by others.

58. Phanetic element I may be expressed by the equation $xy=0$; element III is $x-a=-\sqrt{[a^2-(y-a)^2]}$ (where a is radius); element IV is $y=x$. If the algorithm is ever pro-grammed for machine generation, several operations (for example, the ADJ REV opera-tion of operators 2 and 3, acting on element III) involve but algebraic change of sign (i.e., $x-a=+\sqrt{[a^2-(y-a)^2]}$).

59. Or, 'iconics', a word coined by Watt (1967) to designate, loosely, pictorial linguistics, or the linguistic description of graphic systems.

60. All the designs of Table 8 may be produced with some efficiency using this algorithm except some of the unique designs of *Type 3a* (Nos. 27–31). Space is unavailable for the generation of sixty designs, and readers are invited to communicate with the author should they find difficulty in arriving at or understanding the generation of any particular representa-tive design not illustrated here.

61. This operation is to be interpreted mathematically – that is, operations are read from the least inclusive and most deeply embedded command first. More complex phrase structure generations such as this are similar to Chomsky's (1968:43) transformational operations on phrases within phrases.

62. The syntactic features of this system are not explicit in the algorithm, and relate primarily to the aesthetic rules of balance, appropriate placement on the body, and symmetry. The generative algorithm is actually morpho-phanemic rather than syntactic in that rules generate all the material from phanemic (or perhaps phanetic) primitives, the elements of Fig. 15. Published work in iconics has usually begun with a series of more complex ele-ments. Watt's work on cattle brands, for example, begins with operations on Arabic numerals and Roman letters rather than more lineally-primitive elements. The present analysis, albeit very simple, is to my knowledge the first published work to begin with the phanemic (or, if it be allowed, phanetic) level. Much preliminary research has taken place on more complex systems (cf. Rankin, 1965 on Chinese characters), and on biological images as natural systems (cf. Kirsch, 1964; Lipkin, Watt and Kirsch, 1966). See note 50, p. 121.

63. Just as in a linguistic grammar, 'correct' but non-meaningful utterances are possible, e.g., 'The angry rock laughed a gallon of criteria.'

64. This involves several ontological problems. If we can accept (or consider) the Hegelian dictum, then it might be possible to trace the development of representational design forms. The argument would run that colour contrast, today a primary and initial operator, can perhaps be considered historically an initial dimension along which meaningful designs developed. This seems inadequate, however, for at least two reasons: first, it suggests that the evolving code dictated the representations – i.e., the sign was made to fit the symbol – a conceivable but unlikely situation. Secondly, it gives us no clues as to the direction and determinates of the evolving code. There were available colour limitations, anatomical limitations – but the interplay of these with other determinates of the rules is unclear. These sorts of problems, however, are critically important today, and anthropologists ignore them at their methodological peril (cf. Boas 1955:354).

65. I was never able to spend a continuous period in the field of longer than nine months, and never saw the months of October and November. As the artistic tradition was not the prime focus of research, I do not have photographs of most of the representational forms

discussed (see Preface, p. 2), nor did I see most of the species represented, nor do I have biological identifications for the natural species.

66. Both animals in this photograph are *dūn*, and the artist (who is not, of course, the wearer) informed me that he thought one was male, the other female. The important point he stressed, was that they were *different* individuals – here again form dominant over meaning. When I asked about other representative designs, I found that most were male representations, or that sex was irrelevant.

CONCLUSIONS

67. In discussion of Southeastern Nuba personal art with others, the suggestion is frequently made that the concern with balance and symmetry is a function (cause/effect) of the duo-lineal descent system and the highly structured social organisation. This is in line with the thesis that Gothic minds produce Gothic art. Although certainly there are cultural conse-quences of the peculiar social organisation (as in certain sexual dichotomies congruent with descent ideology – cf. Faris, 1969b), I do not feel any sufficient or necessary causal link exists between the *particular* structure of Southeastern Nuba social interaction and the *particular* structure and form of their art tradition. Without a discernable process to explain correspondences and correlations, they may simply be specious.

BIBLIOGRAPHY

ARNHEIM, R. 1960 [1954], *Art and Visual Perception: A Psychology of the Creative Eye*. Berkeley: University of California Press.

BERLIN, B., D. BREEDLOVE and P. RAVEN. 1968, 'Covert Categories and Folk Taxonomies'. *American Anthropologist*, vol. 70 (2):290–9.

——, and P. KAY. 1969, *Basic Color Terms*. Berkeley: University of California Press.

BERNDT, R. 1958, 'A Comment on Dr Leach's "Trobriand Medusa"'. *Man*, vol. 58 (No. 90): 65–6.

BOAS, F. 1955 [1927], *Primitive Art*. New York: Dover Press.

CARPENTER, E. 1966, 'Image Making in Arctic Art'. In: G. Kepes (ed.), *Sign, Image, Symbol*. New York: G. Braziller.

CHOMSKY, N. 1968, *Language and Mind*. New York: Harcourt, Brace and World.

COLBY, B. 1963, Comment: J. Fischer, 'The Sociopsychological Analysis of Folk Tales'. *Current Anthropology*, vol. 4 (3): 235–95.

CUNNISON, I. 1966, *Baggara Arabs*. London: Oxford University Press.

DETHLEFSEN, E. and J. DEETZ. 1966, 'Death's Heads, Cherubs, and Willow Trees; Experimental Archaeology in Colonial Cemeteries'. *American Antiquity*, vol. 31 (4): 502–10.

FARIS, J. 1968a, 'Some Aspects of Clanship and Descent Amongst the Nuba of Southeastern Kordofan'. *Sudan Notes and Records*, vol. 49: 45–57.

——, 1968b, 'Validation in Ethnographical Description: The Lexicon of "Occasions" in Cat Harbour'. *Man*, n.s., vol. 3 (1): 112–24.

—— 1969a, 'Sibling Terminology and Cross-Sex Behaviour: Data from the Southeastern Nuba Mountains'. *American Anthropologist*, vol. 71 (3): 482–8.

—— 1969b, 'Some Cultural Considerations of Duolineal Descent'. *Ethnology* vol. 8 (3): 243–54.

—— 1970, 'Non-Kin Social Groups of the Southeastern Nuba'. *Sudan Society*, vol. 5: in press.

—— 1971, 'Southeastern Nuba Age Organization'. In: W. James and I. Cunnison (eds), *Sudan Ethnography: Essays in Honour of E. E. Evans-Pritchard*. London: C. Hurst.

—— (forthcoming) 'Nominal Classes of the Southeastern Nuba: Implications for Linguistic Science'. In: R. Thelwall (ed.), *Language in the Sudan*. London: C. Hurst.

FIRST POPULATION CENSUS OF SUDAN, 1955–1956. Khartoum: Government Printing Office.

von FOERSTER, H. 1966, 'From Stimulus to Symbol: The Economy of Biological Computation'. In: G. Kepes (ed.), *Sign, Image, Symbol*. New York: G. Braziller.

FORDE, D. 1965, 'Unilineal Fact or Fiction: An Analysis of the Composition of Kin-Groups Among the Yako'. In: I. Schapera (ed.) *Studies in Kinship and Marriage: Essays in Honour of Brenda Seligman*. London: Royal Anthropological Institute.

GEOGHEGAN, W. 1968, 'Information Processing Systems in Culture'. Language Behaviour Research Laboratory, Working Paper No. 6. Berkeley: University of California.

GIBSON, J. 1954, 'A Theory of Pictorial Perception'. *Audio Visual Communication Review*, vol. I: I.

HASELBERGER, H. 1961, 'Method of Studying Ethnological Art'. *Current Anthropology*, vol. 2 (4): 341–84.

HOLM, B. 1965, *Northwest Coast Indian Art: An Analysis of Form*. Seattle: University of Washington Press.

HURREIZ, S. 1968, Linguistic Diversity and Language Planning in the Sudan. African Studies Seminar Paper No. 5. Khartoum: Sudan Research Unit, University of Khartoum.

JAKOBSON, R. 1965, 'Quest for the Essence of Language'. *Diogenes*, vol. 51: 21–37.

KIRSCH, R. 1964, 'Computer Interpretation of English Text and Picture Patterns'. *IEEE Transactions on Electronic Computers*, E.C. vol. 13 (4): 363–76.

KNOROZOV, Y. 1967, *The Writing of the Maya Indians*. Translated by S. Coe. Russian Translation Series of the Peabody Museum of Archaeology and Ethnology, Harvard University, vol. IV.

KUBLER, G. 1962, *The Shape of Time*. New Haven: Yale University Press.

—— 1969, *Studies in Classic Maya Iconography*. Memoirs of the Connecticut Academy of Arts and Sciences, vol. XVIII.

LEACH, E. 1954, 'A Trobriand Medusa?' *Man*, vol. 54 (No. 158): 103–5.

—— 1958, 'A Trobriand Medusa? A Reply to Dr Berndt'. *Man*, vol. 58 (No. 90): 65–6.

—— 1961, 'Rethinking Anthropology'. In: E. Leach, *Rethinking Anthropology*. London School of Economic Monographs on Social Anthropology, No. 22. London: Athlone.

LEVI-STRAUSS, C. 1963a, *Structural Anthropology*. New York: Basic Books.

—— 1963b, *Totemism*. Boston: Beacon Press.

—— 1966, *The Savage Mind*. London: Weidenfeld and Nicolson.

—— 1969, *Conversations with Claude Levi-Strauss*. G. Charbonnier (ed.). London: Jonathan Cape.

LIPKIN, L., W. WATT and R. KIRSCH. 1966, 'The Analysis, Synthesis, and Description of Biological Images'. *Annals of the New York Academy of Sciences*, vol. 128 (No. 3): 984–1012.

LOUNSBURY, R. 1964a, 'The Structural Analysis of Kinship Semantics'. *Proceedings of the Ninth International Congress of Linguists*. The Hague: Mouton.

—— 1964b, 'A Formal Account of the Crow- and Omaha-Type Kinship Terminologies'. In: W. Goodenough (ed.), *Explorations in Cultural Anthropology: Essays in Honor of G. P. Murdock*. New York: McGraw-Hill.

LUZ, H. and O. LUZ. 1966, 'Proud Primitives, The Nuba People'. *National Geographic Magazine*, vol. 130 (5).

MILLER, G. 1956, 'Human Memory and the Storage of Information'. *IRE Transactions on Information Theory*, I.T. vol. 2: 129–37.

MUNN, N. 1966, 'Visual Categories: An Approach to the Study of Representational Systems'. *American Anthropologist*, vol. 68 (4): 936–50.

NADEL, S. 1947, *The Nuba*. London: Oxford University Press.

—— 1950, 'Dual Descent in the Nuba Hills'. In: A. Radcliffe-Brown and D. Forde (eds.), *African Systems of Kinship and Marriage*. London: Oxford University Press.

OTTENBERG, S. 1968, *Double Descent in an African Society: The Afikpo Village Group*. Seattle: University of Washington Press.

RANKIN, B. 1965, 'A Linguistic Study of the Formation of Chinese Characters'. Dissertation. University of Pennsylvania, Philadelphia.

RODGER, G. 1955, *Les Villages des Noubas*. Paris: Achille Weber.

STABLER, M. 1965, 'Concrete Painting as Structural Painting'. In: G. Kepes (ed.), *Structure in Art and in Science*. New York: G. Braziller.

STEVENSON, R. 1956–7, 'A Survey of the Phonetics and Grammatical Structure of the Nuba Mountain Languages'. *Afrika und Übersee*, Band XL–XLI.

—— 1962, 'Linguistic Research in the Nuba Mountains – I'. *Sudan Notes and Records*, vol. 43: 118–30.

—— 1964, 'Linguistic Research in the Nuba Mountains – II'. *Sudan Notes and Records*, vol. 45: 79–102.

—— 1966, 'Some Aspects of the Spread of Islam in the Nuba Mountains'. In: I. Lewis (ed.), *Islam in Tropical Africa*. London: Oxford University Press.

SWANTON, J. 1908, 'Social Condition, Beliefs and Linguistic Relationship of the Tlingit Indians'. Bureau of American Ethnology, Annual Report, No. 26. Washington: Government Printing Office.

TURNER, V. 1966, 'Colour Classification in Ndembu Ritual'. Association of Social Anthropologists Monograph No. 3, *Anthropological Approaches to the Study of Religion*. London: Tavistock.

—— 1967, *The Forest of Symbols*. Ithaca: Cornell University Press.

WATT, W. 1966, *Morphology of the Nevada Cattlebrands and Their Blazons, Part 1*. National Bureau of Standards Report 9050. Washington: Government Printing Office.

—— 1967, 'Structural Properties of the Nevada Cattlebrands'. *Computer Science Research Review*, vol. 2: 21–8. (Pittsburgh: Carnegie-Mellon University).

INDEX

(page numbers in italics signify Plate, Figure, or Map)